Books are to be returned on or before
the last date below.

LIBREX–

digital travel photography

AVA Publishing SA
Switzerland

An AVA Book
Published by AVA Publishing SA
Rue des Fontenailles 16
Case Postale
1000 Lausanne 6
Switzerland
Tel: +41 786 005 109
Email: enquiries@avabooks.ch

Distributed by Thames & Hudson (ex-North America)
181a High Holborn
London WC1V 7QX
United Kingdom
Tel: +44 20 7845 5000
Fax: +44 20 7845 5055
Email: sales@thameshudson.co.uk
www.thamesandhudson.com

Distributed by Sterling Publishing Co., Inc.
in the USA
387 Park Avenue South
New York, NY 10016-8810
Tel: +1 212 532 7160
Fax: +1 212 213 2495
www.sterlingpub.com

in Canada
Sterling Publishing
c/o Canadian Manda Group
One Atlantic Avenue, Suite 105
Toronto, Ontario M6K 3E7

English Language Support Office
AVA Publishing (UK) Ltd.
Tel: +44 1903 204 455
Email: enquiries@avabooks.co.uk

ISBN 2-88479-082-9

10 9 8 7 6 5 4 3 2 1

Design: Bruce Aiken
Picture research: Sarah Jameson

Production and separations by
AVA Book Production Pte. Ltd., Singapore
Tel: +65 6334 8173
Fax: +65 6334 0752
Email: production@avabooks.com.sg

a comprehensive guide to digital travel photography

duncan evans

contents

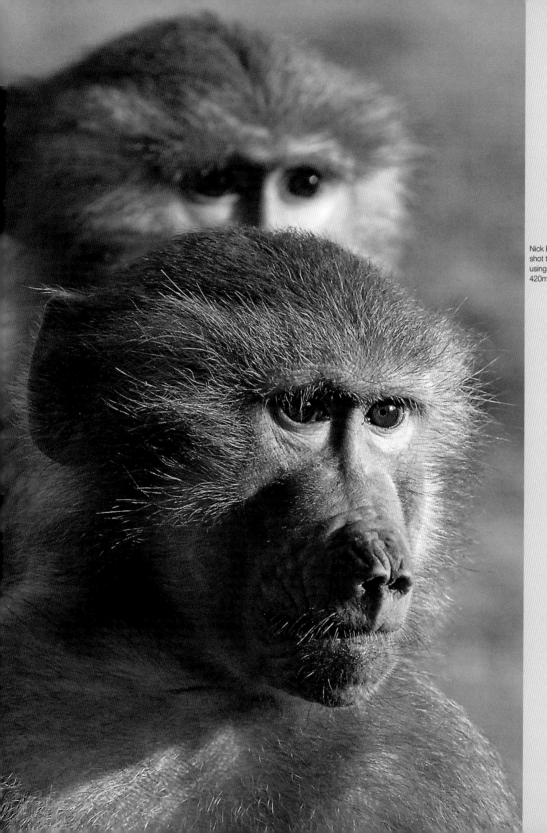

Nick Biemans of the Netherlands shot this photo in a safari park using a Canon digital SLR with a 420mm equivalent lens.

introduction

Travel photography sums up visions of snarling animals on sun-baked savannahs, of jumping, ochre-daubed tribesmen, glistening seas and the pungent smell of exotic spices. For the more adventurous it also signifies towering mountains, ice cold rivers, steaming, spouting geysers and dazzling white snowscapes. When the traveller presses on further into a country, sights beyond the predictable tourist camera fodder make themselves known – lost architecture, street urchins, workers in fields, ancient modes of transport. The real underbelly of a country becomes exposed.

Traditionally, these adventures were the preserve of the rich. The travel fares were expensive and the amount of camera equipment needed was prodigious. Then there were the practical problems of taking films through x-ray machines, hoping they would live in 100 degree heat when the portable fridge no longer worked, never mind actually taking a great picture that you would be happy with later. These days, budget airlines have slashed prices, forcing the bigger companies to respond. The internet provides a handy source of last minute deals and bargain bucket ticket shops. It's never been so easy or cheap – despite perpetual crises over terrorism to travel and to travel far.

Now we bring digital photography into the equation – the biggest revolution in photography since the development of colour film. Digital photography makes it easier to get a decent picture, but can make it harder to get a great picture, unless you know exactly what it is capable of and how to use it.

That's where A Comprehensive Guide to Digital Travel Photography comes in. In this book the aim is to explain clearly what type of camera you will need for differing environments and activities, what accessories you will need to make a successful trip, how to use filters properly and what you can or can't shoot with regards to privacy laws and holy shrines. Then, it's out and about time, with an array of fabulous travel photography images, all explained in a step-by-step fashion with regards to how the photographers shot them and how the images were subsequently improved through digital manipulation.

Firstly, we're off to hot places, covering golden sands, azure seas and brilliant beach locations. Then into the interior with steamy tropical jungles, dry, arid deserts and sweltering meadows and grasslands. The following chapter takes the temperature right back down as cold weather descends, snow falls, rivers freeze and mountains loom majestically, as white capped crowns demanding homage. Travel photography often encapsulates the extremes of temperature and weather, and in these two chapters we deal with those traditional areas.

Travel photography isn't just about landscapes though, it's the people that have sculpted them that are just as interesting. Here we look at portraits in foreign climes, working scenes, candid photography, street scenes and people going about their daily business. Then they get lively, as we move into action events, covering the native population as it engages in traditional sporting pastimes, whether it's rowing boats out

to sea, snowboarding downhill at break-neck speeds or simply slapping foot leather to foot pedal in cycling.

The animals now take centre stage, with big game competing with leaping, splashing sealife. Here the experts explain just how they managed to capture those elusive and award-winning shots of animals in action. We've even got tips on getting great pictures when the animals are a little closer to hand, in safari parks or responsible zoos.

Transportation and the travel infrastructure are an integral part of a country, and of travel photography itself. Whether it's a large, busy airport, yachts bobbing up and down in a harbour, high-performance cars surging through the concrete veins of the city, rickety two-wheeled coaches being pulled by grinning young men or wagons powered by the sweat of animal labour, you will find something to delight and please in this chapter.

After the places and the people, it is the architecture that defines a country and this next chapter is dedicated to it. From shooting typical tourist traps in a refreshing style or from an unusual viewpoint, we move on to forgotten buildings, classy interiors, luxurious palaces and hi-tech, high rise glass and steel buildings, towering up into the night sky.

The final section of the book is aimed at when you return from your travels and you want to make the best of your digital images. Replacing dreary skies, knocking back intrusive depth of field, cloning out distractions and adding new elements are all dealt with to

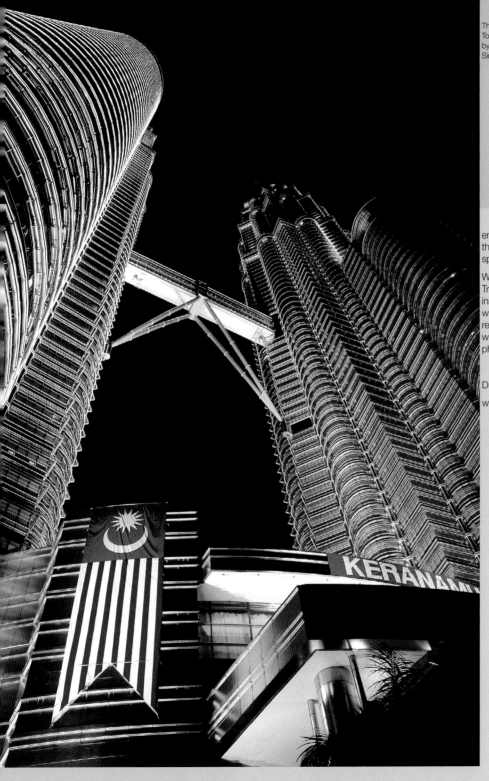

The Petronas Twin
Tower in Kuala Lumpur
by Alec Ee of
Singapore.

ensure that at the end of your journey,
the images match the sights and
splendours that you've seen.

With A Comprehensive Guide to Digital
Travel Photography by your side,
inspiration, information, tips and advice
will help take your pictures out of the
realm of holiday snapshots and into the
world of awe inspiring, digital travel
photography.

Duncan Evans LRPS

www.duncanevans.co.uk

tips

Practical tips from the author and photographer allow the reader to apply issues raised in the images discussed to their own creative work.

how to get the most out of this book

This book is divided into nine chapters. These chapters cover subjects such as preparing to go, hot places, cooling down, shooting people, action events, animal safari, transportation, architecture, and finally, special digital effects. The appendix includes a useful glossary of technical terms together with the photographers' biographical details.

Each spread is self-contained and explains either how specific images have been created in depth, or gives a brief overview of the important steps to accompany a detailed look at a particular technique or feature. Helpful quotes from the photographer or author put a personal slant on the information presented. Everything is explained from the photographers' 'hands on' point of view, not just from a theoretical approach. The design allows you to dip into the book at any stage to gain useful insight, without necessarily having to read the chapters and spreads in order.

The featured work comes from both professional photographers and talented enthusiasts, and there is something for everyone no matter what their approach or starting point.

When using warm-up set the white balance camera manually, other may tune out the effect filter.

temples and tombs

introduction

An overview of the theme and techniques set out in the spread.

Temples of worship, tombs, shrines and the like, are great photographic material, but you need to keep out of the way of the crowds of tourists who may also be visiting. To capture a memorable image, either include tourists so as to give the building a human connection, or shoot it as you would a landscape – wait for fantastic lighting and capture it resplendent in the evening glow.

flow chart

A step-by-step outline of the main stages that the image has gone through is given in a flow chart. This allows a quick reference to the same or similar points of interest on different spreads. The flow chart also enables the reader to determine at a glance how simple or complex an image was to create.

> crop
> selection
> brightness
> invert
> darkening
> red tint
> saturation
> curves
> save for web

118 architecture – temples and tombs

section and spread title

images

The images in this book feature popular travel subjects such as beach scenes, architecture, mountain scenes, street scenes and wild animals. We also explore special digital effects that can be applied to your travel images once you are back home.

shoot – enhance – enjoy

Where possible each spread is divided into the sections 'shoot', 'enhance' and 'enjoy'. 'Shoot' explains the background details up until the moment of capture. The choice of equipment and the context of the shoot are revealed. The 'enhance' section explains the process that the image has been through once in computer, outlining the stunning results that the digital photographer can create post-capture. The 'enjoy' section reveals how the image has been used for personal enjoyment or professional use, and the output method.

creasing or decreasing the
hite balance setting
rond what is actually
sent can be used as a
ital alternative to filters.

shoot

This photo was taken by Lyle Gellner of Canada, at the Qing tombs (1644–1911) using a consumer digital SLR from Nikon. The Qing tombs are visited less than the Ming tombs, owing to their relative remoteness from Beijing. Located in Zunhua county, this death valley houses five emperors, 14 empresses and 136 imperial consorts. In the mountains ringing the valley are buried princes, dukes, imperial nurses and more. The perspective is directly into the last rays of sunlight filtered through the haze on the distant mountain horizon. An 81c warm-up filter was used to enhance the image.

2 crop

3 levels

enhance

The image was cropped to make for a better composition that followed the rule of thirds (2).

The lower portion of the image, including the trees and tomb, was selected and levels used to increase the brightness (3).

The selection was inverted so that the sky and distant mountains could be darkened using levels (4).

A red tint was added and the saturation increased (5). The final adjustment was to use the curves control.

1/ A decent sunset behind an old temple tomb, four hours' drive from Beijing in China.

2/ The image was cropped.

3/ Levels was used to increase contrast.

4/ Inverting the selection in levels, the sky and distant mountains could be darkened.

5/ Finally a red tint was added to the sky.

6/ With the enhanced red colour, this shot now has dramatic impact.

captions

The image captions clarify and recap the processes shown in each image.

4 levels

5 photo filter

screengrabs

Often detailing the exact settings used for key stages of the photo-editing process, screengrabs provide a quick and instructive visual check with which to follow the proceedings.

enjoy

The image has been printed out for personal use and Lyle also resized it for website use. The image was then sharpened slightly before saving as a JPEG.

6

119

1 preparing to go

Pack up your bags, ready your equipment and consult the guide book, it's time to get everything ready for our photographic adventure. Before you depart for exciting locations, exotic wildlife and interesting people, stop to consider what you really need to take, what filters you should have in your bag, how much storage is considered adequate and what not to shoot when you get there.

This picture of a rocky shoreline at sunset was shot by Markos Berndt of Milwaukee, USA using a Minolta consumer digital camera with a neutral density filter.

Markos says: 'I had noticed this series of rocks for a while, I just never photographed them as the water was too high or the sky wasn't as dramatic as I normally like. I used a graduated ND filter and long exposure to make the rocks stand out more.'

photographers

Markos Berndt
Duncan Evans
Erik Lundh
Marco Pozzi

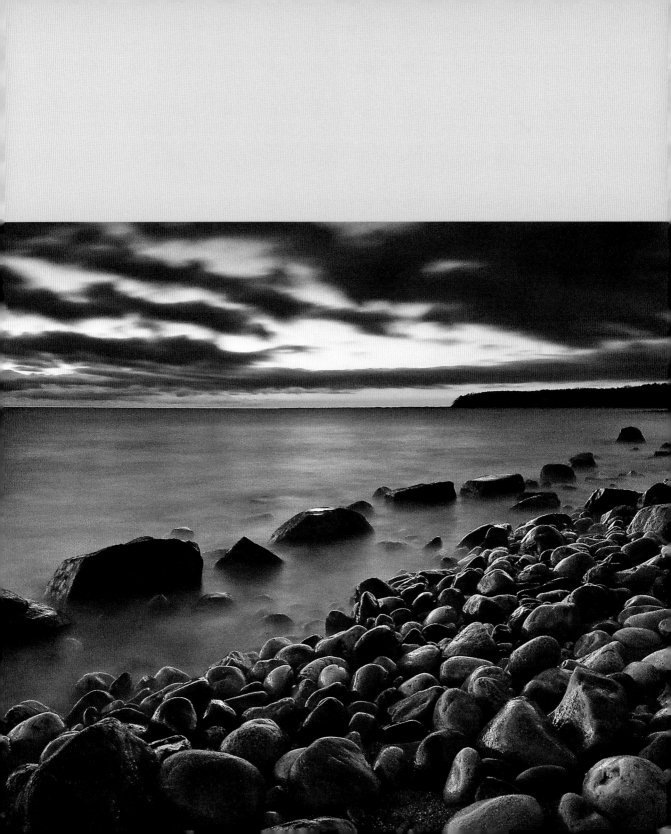

1

taking the right camera and lens

When travelling abroad it's important to match your digital camera equipment with the type of photography you'll be doing. While the professionals can pack any amount of hardware, for the enthusiast it's usually the camera you've got and that's it. However, if you do have a choice, or are considering buying a camera to take away, then it's important to get it right. A general rule is that for landscapes you will need a camera with at least a 6Mp resolution. For portraits of people or animals then 3Mp or better will suffice.

wildlife

If it's animals roaming across the land that's your objective, then the most important thing to have is a long lens – at least 300mm for SLRs as this will translate into around 450mm effective focal length, thanks to the focal length multiplier. This is caused by the CCD or CMOS chip being smaller than the equivalent piece of film, yet being placed in the same position in the camera. For compacts you are talking about one with a 10x optical zoom, which gives an effective reach of around 350mm.

candid portraits

For shooting people in the landscape a relatively long lens is required so that you can shoot without being observed. Something along the lines of 200mm will do the job. For flexibility and to get closer shots, a 28–200mm zoom won't break the bank and will get you the shots. In the world of compacts, a 5x–7x optical zoom will give you up to 245mm reach, but bear in mind that if the camera starts with a wide angle of say 28mm, then saying it has a 7x optical zoom will only take that reach up to 196mm.

landscapes

As mentioned, resolution is king in the world of landscape photography, travel orientated or not. To capture the full panorama of the vista in front of you, without having to go to the effort of stitching images together, you need a wide-angle lens. The only trouble is that for digital SLRs, that focal length multiplier that proved so handy for telephoto lenses now counts against you. A standard 28mm lens that offers a wide field of view, without introducing distortion, actually gives a less-than-useful 42mm focal length. To get even the decent wide angle of 28mm you need an actual lens of around 18mm, which does give significant distortion. Fortunately this is mainly around the edges of the lens and this is the part that the digital camera doesn't use. On the compact front, it's a simple matter of looking for one that has a wide angle end, and many do offer that 28mm equivalent field of view.

1/ The Minolta DiMAGE A1/A2 range offers a 28–196mm optical zoom range on a compact body, ideal for candid portraits.

2/ The Canon EOS 300D digital SLR with an 18–55mm wide-angle telephoto lens – ideal for landscapes.

3/ This Sigma 28mm–300mm super zoom would give the equivalent of 42mm–450mm on most digital SLRs, making it a handy lens for wildlife photography.

action events

If you want to freeze the action as it happens, then your gear needs to have a couple of specific characteristics that will get you the shot. The first is that it should have a fast shutter speed. How fast depends on the action you are capturing, but it will need to be 1/500th sec for anything moving as fast as a bicycle, and up to 1/2000th sec for very fast events. Now most digital cameras can manage up to 1/1000th sec, SLRs or compacts,

and for the majority of events this is fine. More importantly, it's the widest aperture setting of the lens that will determine whether you can get a shutter speed anywhere near the maximum. Digital compacts have a huge advantage here as they routinely will offer f2.8 or f3.5 up to the maximum end of the telephoto zoom. Some can better even that. For SLRs, to get a 200mm lens with a f2.8 aperture won't be cheap. When you start talking about 300mm

and f2.8 in the same breath the cost really rockets. If this kind of photography is what you want, then buy a lens with a wide maximum aperture, at the expense of losing telephoto reach.

3

2

crowd scenes

When you are in amongst the populace, your SLR might produce great results, but it will make the local population far more wary of you. There is also the security aspect to consider as you and your expensive camera will stand out like a sore thumb. Much more discreet is the 5Mp compact with a zoom that can be out and shooting before people start to react to having a photographer amongst them.

! Avoid having to buy the same filter for lenses with different size threads by buying a thread adapter for the filter holder. This can then be swapped for each lens, allowing the full range of your filters to be used for all.

essential filters

Just because you are using a digital camera and have access to the power of photo editing, doesn't mean you should ignore some of the more useful filters. The starting point for any discussion of essential filters is surely the UV or skylight filter. This is usually available in the form of a screw thread, circular shape that can be fitted right on to the end of the existing lens. So, not only does it offer the ability to reduce UV glare, it also acts as permanent protection for your lens. Simply leave it on all the time as it has no effect on picture quality or shutter speed.

polariser

The polariser is rightly lauded as being the landscape photographer's best friend as it has the ability to make skies darker and bluer. This is also a circular filter, but fits into a holder where it can be rotated. As this is done it affects light passing through so that it can block reflections on glass or water, or make colours deeper and stronger. It's ideal for using with lakes or rivers as it gives the option of making the surface of the water highly reflective so that it mirrors the clouds and sky, or virtually translucent so that you can see right through it. As far as enhancing colours goes, it works best when used at 90 degrees to the sun, however, the effect is not quite the same as when it is used with film. It makes the colours deeper and darker, but not really any stronger. What you do need to be wary of is that a polariser will reduce the light coming into the camera by one to two stops. That's fine when used with a tripod, but it needs consideration when the camera is being used hand-held as there is the potential for camera shake thanks to a slow shutter speed.

neutral density

Possibly the most useful filter is the graduated neutral density (ND) filter. This goes from clear to grey, either gradually, where it's known as a soft filter, or with a much sharper transition, whereupon it's known as a hard filter. The use of this filter is to balance the exposure of the sky and landscape, where one (usually the sky) is considerably brighter than the other, which would otherwise lead to highlights being lost in the sky or the landscape being much too dark. A related filter is the regular ND, which has a single density of grey across the entire filter. The filter comes in various strengths and its purpose is to reduce the light coming into the camera for creative effects, usually involving water. If you want slow-motion photos of cascading waterfalls, then one or two ND filters can reduce the light right down without colouring it, and give you the long exposure required for blurring the water.

1/ The circular polariser is invaluable in landscape photography.

2/ Markos Berndt took this photo of Witnall Falls, Wisconsin, USA using a graduated neutral density filter to balance the exposure, and a circular polariser to ensure the reflection of the trees could be seen to maximum effect.

! Buy one UV or Skylight filter for each lens you have and screw them on. A damaged filter is cheap to replace, a damaged lens isn't.

other filters

Those are the filters that are the most use, there are others for specific purposes like the soft focus filter that makes everything look soft and dreamy – handy for portraits where you want to flatter the subject. The use of standard warm up and cool down filters needs more care and attention and the value of them is largely down to how the white balance control on your camera works and how flexible it is.

The AWB (automatic white balance) is designed to correct colour casts so if you simply stick a warm-up filter in front of the lens, the camera's AWB will simply treat it as a colour cast and try to correct it. Cool filters are largely used to correct colour casts for film, and are less useful for landscape travel photography than the warm-up filter range – the 81 and 85 series of filters. As the strength of the warm-up filters is more predictable than what a false manual setting of the white balance might do, there is a certain merit in setting the white balance to match the lighting conditions and then using the warm-up filter to make the light more pleasant.

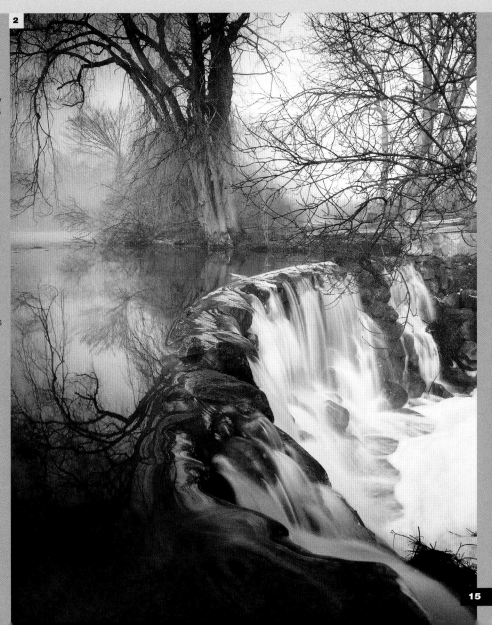

2

useful accessories

So what should go in the kit bag alongside the sun cream and camera? Well for a start you need to check what the local voltage and plug requirements are. Digital cameras gobble power and it's a fact of life that if you want more than a handful of photos, you're going to need to recharge somewhere. If necessary invest in plug-pin changers and/or a voltage converter for the country you are visiting. Stock up on rechargeable batteries so that you have one set in the camera and at least one spare, if not two. Then make sure you have a battery recharger – preferably a fast one.

space and space

With power requirements taken care of, the next most important thing is storage. While the resolution of the camera may dictate how large the files are, there is something you can do to save space. Ask yourself, do you really need TIFF files or will high quality JPEGs do? For most uses you cannot tell the difference between a maximum quality JPEG and a TIFF file, but the space saving can make a huge difference to how many pictures you can get on a card. For example, put a 1Gb memory card in a 6Mp camera. Shooting TIFFs you will only get 58 pictures, but switch to JPEGs and that shoots up to 438.

Once you've decided on what format you will be shooting, you can make a good judgement as to how much

storage and what type you need to take away. If you are shooting max quality JPEGs, then two 1Gb cards will surely see you through the holiday no matter how prolific a snapper you are.

If on the other hand you need to shoot TIFFs, then the choice is either to invest in more memory cards or take a portable storage unit with you. This can be a laptop with a decent size hard drive (minimum 40Gb) if you are engaged in serious photography, as this will enable photo editing and selection to take place as well. You will need to convert the power supply for the laptop as well mind you.

The other option is what amounts to a hard drive with an interface. There

are a number of these type of devices that are simply portable media storage units offering 20Gb or more storage space. All you have to do is connect your camera to it and download the pictures on to the plentiful hard drive, freeing up your memory card for the next day's shooting.

For landscape, night time or long exposure work, it really pays to have a tripod. Pack it in your suitcase and the extra weight won't seem as onerous, but if you have a choice of tripods, then a lightweight one obviously makes more sense.

If travelling to a humid climate then a cloth to wipe the lens with would be advantageous. Beware of wiping it

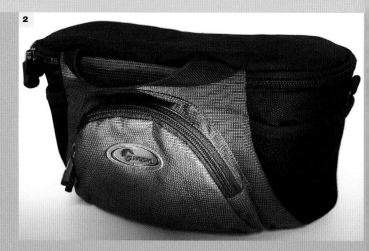

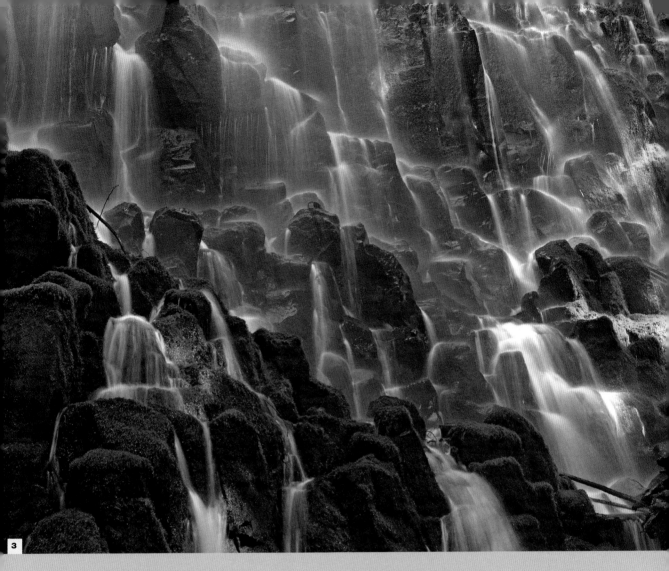

3

though if you are in a sandy or dusty location as this might well scratch the lens. Get a little air blower – either a manual pipette-like device or a can of compressed air, to blow any muck off the lens.

For the more affluent or those engaged in more professional pursuits, then having a bluetooth mobile phone that works in the country you are heading for, can be very useful. With a suitably equipped camera, or more likely, a laptop, you can wire photos back home or to a picture desk almost as soon as you

have shot them. At the very least, a mobile phone is a vital accessory when travelling into less frequented areas, though reception may be a problem.

Finally, it might seem blindingly obvious, but a sturdy camera bag to pack lenses, camera and memory cards in will help protect your investment while out and about, and also keep it away from covetous eyes. The last thing you want to do is walk around with the camera around your neck as the first less-than-salubrious place you visit will be

when you and your hardware part company. And probably your wallet/purse with it.

1/ If power is king in the world of digital cameras, then the battery charger is its chief advisor. Ensure you have one when you travel.

2/ If carrying a compact camera, then a tidy bag like this is all you need to keep it safe and sound.

3/ If you want to take long exposure photos like this by Erik Lundh then you will need to pack a tripod to take with you.

> **!** There is generally far more restriction on shooting people than places. Ensure you are familiar with the country's laws if you intend to engage in mainly travel portraits.

> **!** Even if you don't place any value on your own neck, if you are travelling off the beaten track then insurance for your camera equipment is absolutely essential.

> **!** Bear in mind what type of government runs the country you are visiting. What one authority may see as benign and harmless, another may see as spying. I refer you to plane spotters in Greece ending up behind bars for photographing planes at an airfield.

what not to shoot

While travelling or visiting countries, the temptation to shoot everything you see can be almost irresistible. However, this can cause offence, land you in hot water with the law or even put you at personal risk. Privacy laws vary from country to country so what may be permissible in your homeland can be infringing the law in others. If you are engaging in commercial photography, the laws tend to be even stricter, so a phone call to the embassy of that country while still at home will help clear up the situation before you set off.

privacy

A general rule of thumb is that if you are on public property and the subject you are shooting is also in the public domain, then go ahead and shoot. However, this cannot cross over into harassment. It's not just good manners to desist if someone makes it clear that they don't want to be photographed, this is an area where you can run foul of the law. It's also a fact of life that while you can be engaged in a perfectly legal photographic exercise, the subject may not want to be photographed. Dialogue can therefore be very important. If someone is going about their work and that would make a great photo, but they aren't keen, then try to explain why you want to photograph them, and perhaps offer a small fee.

Shooting into private property may seem like an obvious thing not to do, but not all private property carries the same weight. Photographing someone in their house is a clear infringement of their civil liberties, but what about someone working in a field? The field is still private property, but the worker in the field is a classic travel photography image. So, rules can be bent at times, but the key thing is to be careful.

As far as shooting people going about their business goes, it pays to be circumspect. Being unobtrusive in crowd situations can produce great candid photos, but if you stroll down a street, particularly in a deprived area where there is real poverty, with an expensive camera swinging around your neck, trouble may ensue. That's nothing to do with the rights or wrongs of the law, it's plain common sense.

Grief is one of those moral minefields. Photographs of people grieving can be incredibly powerful, and if the reason for that grief is one that has a wider implication or relevance, then there is good reason to take it. If it's an entirely personal trauma to that family, then you start to border on sensationalism and outright intrusion. Also, when it is something that has no wider implications, then the sight of a foreigner snapping away can both upset and enrage the local population. In these circumstances it is usually better to err on the side of caution and not intrude.

Situations that can be fraught with difficulties generally revolve around religion, in terms of sites, shrines and people practising it. You should be aware of the customs and general practices at religious locations and always ask permission, or note that photography is allowed because there are dozens of other people snapping away. If a follower, priest or monk expresses a wish not to be photographed, then you should respect that and put your camera away.

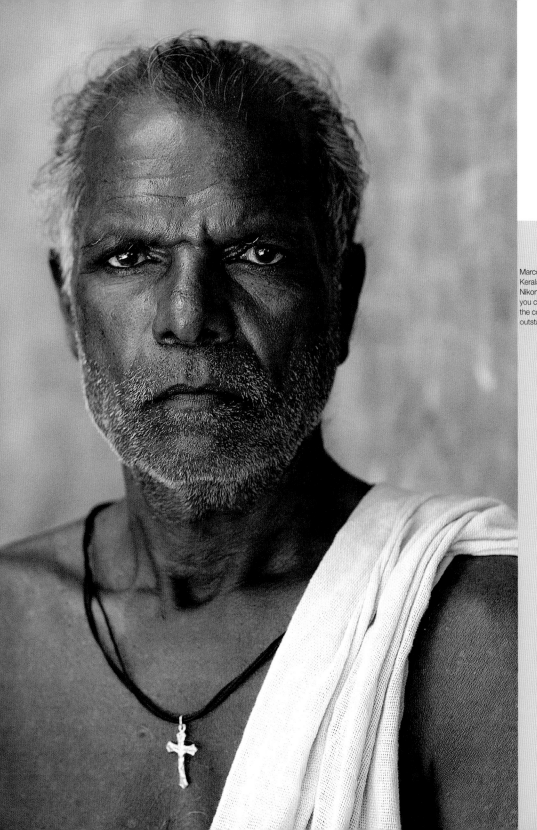

Marco Pozzi shot this image in Kerala, southern India using a Nikon consumer digital SLR. If you can involve the subject then the co-operative result can be outstanding.

2 hot places

Hot places immediately conjure up images of travel and adventure. From desert plains, towering dunes and leafy watering holes, to pristine beaches with tropical palm trees swaying, or steaming paddy fields with workers toiling. There are numerous opportunities for the travel photographer in hot climates. Simply the sheer heat has led to different dress styles and lifestyles, along with bleached white architecture, designed to keep out the sun. So, pack up your sun cream along with your camera and go where the sun shines.

Hassan Ahmed shot this image of a life buoy with a Nikon consumer digital camera and a Sigma 24mm lens in Pescara, Italy.

Hassan says: 'It was 4pm in the afternoon and this stretch of the beach was deserted. It was very hot and the only thing visible was the life buoy so I tried to create a minimalist, artistic photo of the scene.'

photographers

Hassan Ahmed
Detlef Klahm
Thomas Muus Stensballe
Julius Wong
Michael Boyer
Rob Gray
Warren Ishii

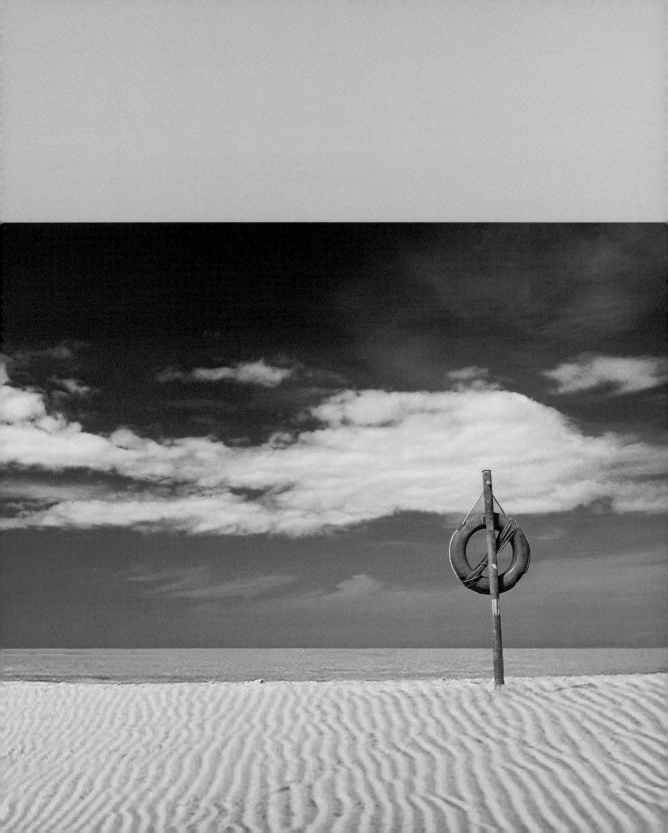

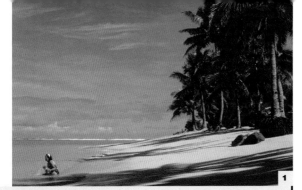

! Sand will wreck the CCD sensor in your camera, so try to avoid changing lenses on the beach if there is any wind.

tropical beaches

There can be few places as indicative of travel to hot climes, than the tropical beach shot. Just getting there is more than many people ever achieve, so make sure your camera is primed and ready. As with most landscape photography, early morning or late afternoon and sunset are the best times to shoot, but if you want people on the beach in the shots, then the late afternoon slot is the one to go for. Aim to capture the heat, the dazzling sand and sea and the relaxed atmosphere.

shoot

Detlef Klahm was in the Cook Islands, at Raratonga beach when he took this picture with his Nikon consumer digital camera and a Tamron 28–300mm superzoom lens. Such was the beauty of the islands that Detlef spent his entire time photographing the scenery, rather than relaxing on the beach.

enhance

The first task was to brighten the image and add contrast. This was done by using the levels control (2).

There was some digital noise in the shadows of the trees so this was removed by using the blur brush and softening those parts (3).

Selective saturation increases were applied to the sky and trees by picking out the colour in the edit box of the hue/saturation control (4). The colour of the sand was then shifted using the hue option to make it more

2 levels

like the actual colour on the day.

An s-shaped curve was applied to darken the shadows and brighten the highlights (5), giving the image much more contrast.

As there was some noise in the sky, the despeckle filter was run to smooth it out a little, then the unsharp mask filter was applied to

3 blur brush

! Check the exposure as the highly reflective sand and sea can fool the metering and lead to a photo being very underexposed. Although this can be corrected, it will introduce digital noise into the picture.

4 hue/saturation

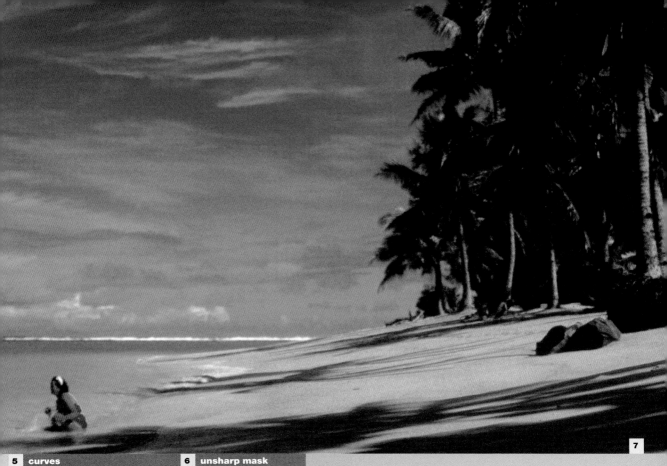

5 curves

Channel: RGB

OK
Reset
Load...
Save...
Smooth
Auto
Options...

Input: 180
Output: 201

☑ Preview

6 unsharp mask

OK
Reset
☑ Preview

Amount: 100 %

Radius: 3.0 pixels

Threshold: 3 levels

enjoy

Detlef puts his images on his website, uploads them to online photo forums, enters camera club competitions and has them for sale. This image has not been sold so far. For use on the web, Detlef changes the image size, adds a border with the name of the print and a copyright notice and saves it as a compressed JPEG.

sharpen the image up (6). This was applied with quite high strength as the image was soft.

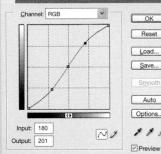

A polariser filter is ideal for accentuating the colours of the sea and sky.

1/ The original photo shot by Detlef Klahm was underexposed thanks to the metering being fooled by the bright light.

2/ Levels was used to brighten the image and add contrast.

3/ Digital noise was removed using the blur brush.

4/ The hue/saturation control was used to increase saturation in the sky and trees.

5/ The shadows were darkened and the highlights brightened using the s-shaped curve.

6/ After using the despeckle filter, unsharp mask was applied to sharpen the image.

7/ With the brightness and contrast adjusted, the colours sorted out and some sharpening applied, the image of the tropical beach is now revealed.

! Use a long lens with a wide aperture to throw everything else on the beach out of focus.

1

beach close ups

Unless you are lucky enough to be in such far flung places that you are faced with miles of empty beaches, then there are usually people around. Shots of people on the beach have to be carefully considered to avoid them simply looking like holiday snaps, so why not go for an abstract close up. This illustrates the hot weather, the pristine sand and blue skies, but also adds a human component.

shoot

Thomas Muus Stensballe shot this image with a Canon consumer digital SLR and a 24–85mm short telephoto lens. Thomas, who is from Copenhagen in Denmark, was on holiday in Portugal for a week when he came across this beautiful girl on the beach. He was struck by the purity of the components in an abstract composition, and particularly the unusual nature of the material used in the side of the bikini bottom. To that end he has called it 'Snake in Paradise'. He asked if he could take some photos and she said yes.

2 **clone stamp**

3 **levels**

5

1/ Thomas spotted the potential of this shot and asked the subject for permission before shooting.

2/ The clone stamp was used to remove the plants sticking up behind the girl's back.

3/ Added contrast was achieved using levels.

4/ The colours in the image were enhanced using hue/saturation.

5/ With the distracting elements removed, this is now a perfect abstract close up on the beach.

4 **hue/saturation**

enhance

The plants appearing behind the girl's back in the distance were removed using the clone stamp tool (2). This was also used to remove the towel underneath the girl.

The levels were adjusted to give the image a little more contrast (3).

Finally, the saturation was tweaked to bring up the colours of the sky, sand and skin tones (4).

> digital capture

> clone stamp

> levels

> saturation

> resize

> save for web

> CMYK

! If you can get permission from someone you'd like to photograph then it makes the process much easier as there won't be any suspicious looks in your direction.

! Include some small detail that lifts the image above the ordinary. This can be an unusual design on clothing, tattoo, or jewellery.

enjoy

Thomas often makes prints for exhibitions and usually sells the pictures that are on display. This picture hasn't been sold yet, but he has high hopes. The image was converted to CMYK for publication in this book and a low-res version prepared for display on his website.

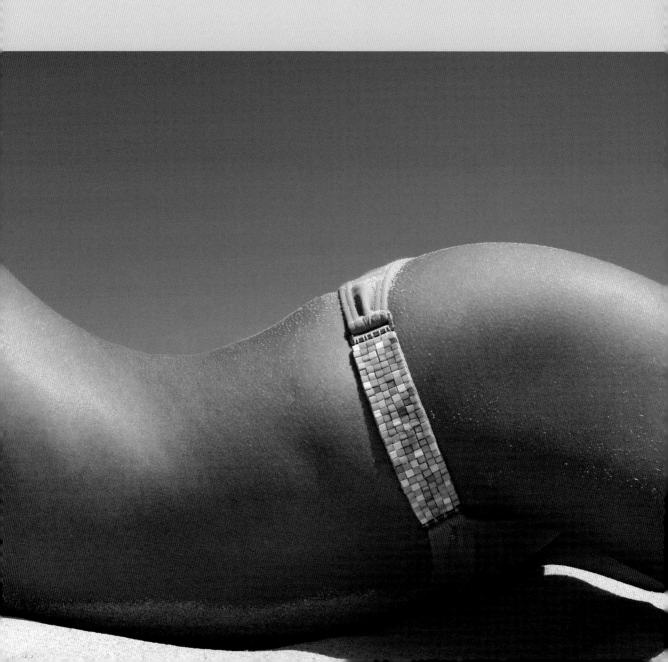

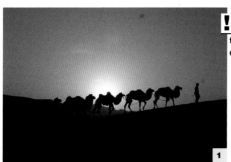

! Don't spend any amount of time pointing the camera at the sun as the bright light can damage the camera sensor.

! Use centre weighted or spot metering with a reading off the bright sky to turn the foreground into a silhouette.

1

desert silhouette

There are few sights as evocative of the desert as the camel, particularly when there is a caravan of them. These ships of the desert immediately conjure up myriad associations with locations, cultures and even films. To make the best of this kind of shot, you should aim to give some sense of scale or isolation as the hardy animals trek through the merciless terrain.

shoot

Julius Wong of Hong Kong was visiting Turfan in the Xinjiang Uyghur Autonomous Region of China when he saw this man leading a camel caravan against the setting sun. Julius loved the desolate surrounding and lighting so took a snapshot with his Canon consumer digital SLR with EF16–35 f2.8L USM lens. Later, he used Photoshop to change the colour of the sky to blue in order to make the image more dramatic.

2 resize

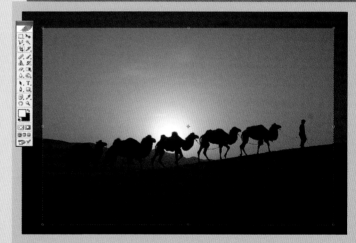

1/ The original image of the camel caravan is dull and lacking in contrast and colour.

2/ The image was resized for printing.

3/ For a tighter composition the image was cropped a little.

3 crop

4 clone stamp

enhance

The image was shot as a RAW file so this was converted first then loaded into Photoshop. It was resized to make it much larger for printing and commercial use (2).

The image was cropped a little to make the composition tighter (3). Then a big dust spot was removed using the clone stamp tool. Also, a baby camel, who was partially obscured by his mother, was then

> digital capture
> RAW conversion
> resize
> crop
> clone stamp
> curves
> hue/saturation
> unsharp mask

5 hue/saturation

Edit: Reds 2

Hue: -180

Saturation: 0

Lightness: 0

OK
Cancel
Load...
Save...

316°/348° 52°\85°

Colorize
Preview

6 unsharp mask

OK
Reset
Preview

100%

Amount: 100 %

Radius: 3.0 pixels

Threshold: 3 levels

4/ The clone stamp was used to remove dust spots and also one camel that was partly obscured.

5/ After increasing the contrast and saturation, the sky colour was changed to blue.

6/ The unsharp mask filter was used to sharpen the image.

7/ After processing, the image now shows the camel caravan in silhouette against a dramatic blue sky.

removed (4). The contrast and saturation were increased then the sky colour was changed to blue (5). Finally, the image was sharpened using the unsharp mask filter (6).

enjoy

Julius makes prints for his own enjoyment and exhibition in photography clubs. He also posts pictures for critique on the Photo.net website.

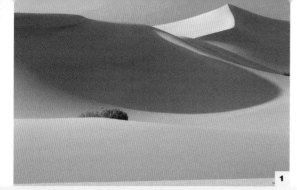

> Sand is almost as reflective as snow. Factor in +0.3 exposure compensation to avoid undue underexposure.

improving composition

There is little to compete with the stark, arid desert for suggesting that you are somewhere extremely hot, where water is scarce and life is marginal. The desert conjures all manner of expectations and associations, and makes a perfect travel photography subject. It's the sweep of the dunes, formed by the wind, that makes for the ideal subject, rather than a flat expanse, so look for curves, shapes and contrasting shadows.

shoot

Michael Boyer of Hayward, California, USA shot this picture of the Mesquite Dunes in Death Valley with a Nikon consumer digital SLR and a Nikon 28–70mm f2.8 ED IF telephoto lens. This was his first trip to the dunes of Death Valley and he spent three hours before dusk walking around the dunes taking as many shots as possible at various locations. Michael did this so he could take the results back and learn about what worked and what didn't, in order to reshoot the following day. Unfortunately the weather didn't cooperate, so he had to edit this photograph in Photoshop instead.

3 crop

2 greyscale

4 levels

enhance

The image was converted to monochrome by changing the colour mode to greyscale (2).

It was then cropped to include only the right half of the photo, highlighting the dune's peak as well as the shadows and lines created by the sun (3). The levels were adjusted to darken the shadows (4) and then a small amount of sharpening was carried out with the unsharp mask.

> digital capture
> greyscale
> crop
> levels
> unsharp mask
> sRGB
> resize for web

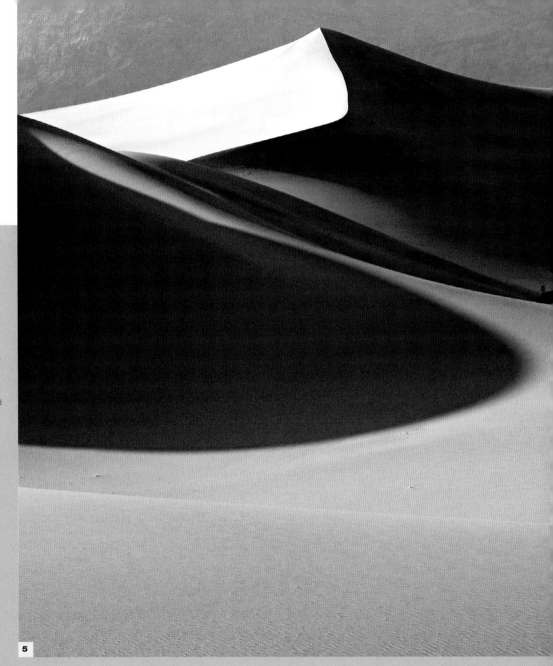

> ! Sand is extremely abrasive and will damage a lens given the chance. Keep your camera in its bag when not shooting.

1/ The original shot is poorly composed, but bad weather prevented a reshoot.

2/ To make the image monochrome the colour mode was changed in greyscale.

3/ The image was cropped to make it stronger compositionally.

4/ Levels was modified to make the shadows darker.

5/ With cropping and tonal adjustments, Michael Boyer produced the picture he wanted of these wind-swept, desert dunes.

5

enjoy

Michael makes prints for his own enjoyment and submitting to online competition sites. For online use, he converts to sRGB, then resizes so that the shorter side is 480 pixels. He then uses the unsharp mask to sharpen the photo to his liking.

> ! A UV or skylight filter will help protect your lens from the desert as well as reduce UV light pollution.

> **!** Get down low, at or below the eye level of your subject, no matter how small it is. To this end have at least one camera without the extra battery pack or with a removable one, as this will allow you to get another 20–30mm closer to the ground.

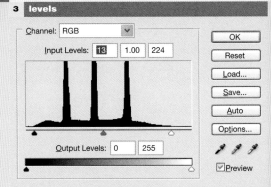

1

solving dust problems

2 dust removal

If there's one thing you can count on in a desert, it's a lack of water. No matter how tenacious the plant life, when faced with an encroaching desert, invariably the result is death. Finding dead trees and photographing them within the desert simply adds to the impression of a deadly and harsh environment, where even trees find it too hard to survive.

shoot

Rob Gray of Australia was planning to take a panorama and had set up the tripod and camera on the side of a cliff for that purpose. He was in the Simpsons Gap at the MacDonnell ranges in central Australia. While sitting on the rock ledge waiting for the light, he looked around and noticed that the moon had risen and would be beautifully juxtaposed with the tree within seconds. There was just enough time to remove the consumer Canon digital SLR from the tripod, swap lenses for a 70–200mm f2.8 zoom with a 2x converter, and grab a couple of shots. Rob shot hand-held because of the time required to swap heads on the tripod.

1/ The original capture was let down slightly by dust on the camera sensor.

2/ Sensors get dirty so check whether dust needs to be removed.

3/ Levels was adjusted and some cropping was carried out to give the image more punch.

4/ With contrast enhanced and the image cleaned up, Rob Gray has a powerful image of life in the desert.

enhance

This particular shot mainly required dust removal as the sensor had become a little dirty (2).

Then there was a slight adjustment of levels and some cropping to finish off with (3).

> digital capture
> dust removal
> levels
> crop
> resize for web
> sharpening

3 levels

Channel: RGB

Input Levels: 13 1.00 224

Output Levels: 0 255

OK
Reset
Load...
Save...
Auto
Options...

☑ Preview

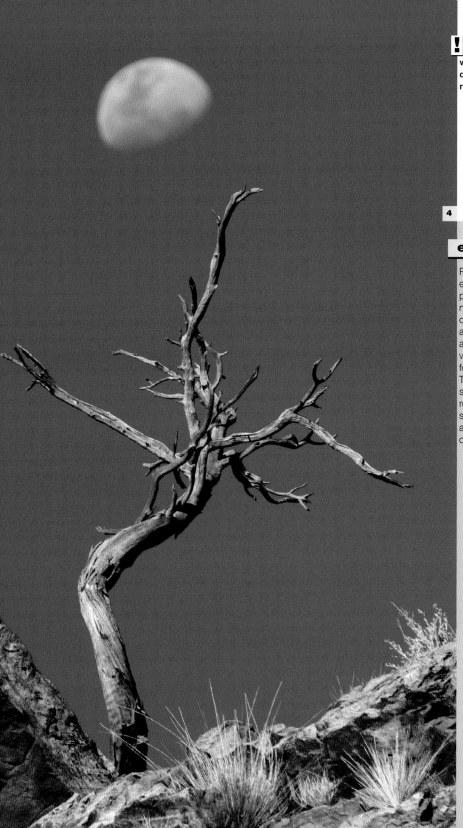

Always have a UV or skylight filter fitted over the end of your lenses when shooting in harsh climates like deserts. One piece of sandy grit can ruin a lens.

4

enjoy

Rob produces prints for sale, exhibitions, and personal viewing. This particular shot is quite recent and has not yet sold or been exhibited. The cleaned up file was archived onto DVD and a low-res (usually 600 x 400 pixel at 72dpi) version created. This low-res version was sharpened as appropriate for the image, then saved as a JPEG. The JPEG compression level was selected manually as all images respond differently. Rob aims for a file size of 70k–80k, but some look good as low as 15k, while others still show compression artefacts at 100k.

! A long exposure on fast moving water will turn it into a blur. Where the water is going back and forth over rocks, it produces a more ethereal result.

! Use a tripod for the long exposure and keep the ISO rating down to 100 for maximum quality.

seascapes at dusk

Capturing the last light at a dramatic location tends to lend itself to great seascape photos. When you do it on a Pacific island chain where the surf pounds the volcanic rock, the drama is increased significantly. Remember to bring a tripod and capture the rock formations or coastal scenery that marks the place out.

2 curves

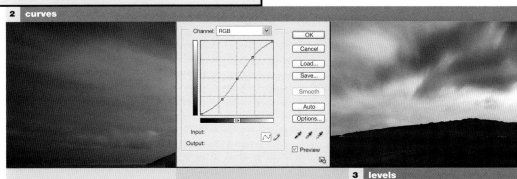

3 levels

shoot

This seascape was photographed on the eastern shores of the island of Oahu in the Hawaiian Islands by Warren Ishii using a Canon consumer digital SLR with a 16–35mm 2.8L wide-angle zoom lens. The sun sinking into the Pacific on the other side of the western end of the island was reflected in a last glow of colour in the south-eastern sky, which was already in twilight. An aperture of f16 was combined with a 30-second exposure, which turned the raging surf into an ethereal seascape.

enhance

The image was converted from Canon's RAW format and the image imported into Photoshop. Then levels, curves and hue/saturation adjustments were applied to the sky (2/3).

4 noise reductions

The same process was then applied to the water and shoreline so that they matched the sky.

The image was cleaned up using the clone brush and the noise from the long exposure was reduced with a filter (4). The image was finally sharpened with the unsharp mask filter (5).

> digital capture

> RAW conversion

> levels

> curves

> hue/saturation

> clone brush

> noise reductions

> unsharp mask

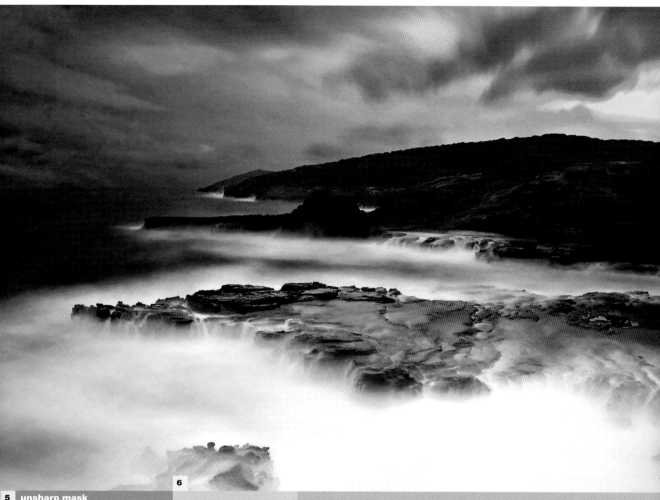

6

5 unsharp mask

OK

Reset

☑ Preview

Amount: 100 %

Radius: 3.0 pixels

Threshold: 3 levels

! **Use the tools of the digital imaging trade to make your original image resemble the scene you actually saw.**

enjoy

Warren enjoys making his own prints and says of this image: 'This is a true photograph exemplifying the synergy of photographic technique, digital editing, and nature's beauty. It is not a digital art manipulation.' The picture won 1st place in the Nature/ Landscape category of the DPC photo contest. This is the world's largest web-based, publicly judged, photo contest.

1/ The original digital file here is flat, dull and devoid of colour – hardly the scene at the time.

2/ Curves was applied to the sky area.

3/ Levels and hue/saturation were also applied to the sky area.

4/ Dust and scratches were removed using the clone brush and the noise from the long exposure was reduced with a filter.

5/ Unsharp mask was used to sharpen the image.

6/ After substantial digital reworking the full glory of Warren Ishii's shot is revealed.

3 cooling down

Unless you actually live in an icy, snow-swept region of the world, you are likely to view snow with fond memories from your childhood. For the photographer, it can turn a regular landscape into a chocolate-box, or Christmas card cover, instantly giving a setting a pure and traditional resonance, deserved or not. At higher altitudes snow wreaths mountains, giving contrast to grey rock, whereas at extreme latitudes, everything starts to freeze, turning the world into a crystalline wonderland.

Markos Berndt of Milwaukee, USA shot this picture with a Minolta consumer digital camera.

Markos says: 'I liked this rock even without the ice on it, but the way the ice has formed on it from splashing waves makes it even better. I was lucky it was a very calm morning, so I could slide down an escarpment to get to this rock. It provided an excellent foreground for the sky, with the sunlight reflecting off the ice.'

photographers

Markos Berndt
Krys Bailey
Heather McFarland
Chris Pastella
Karl Baer

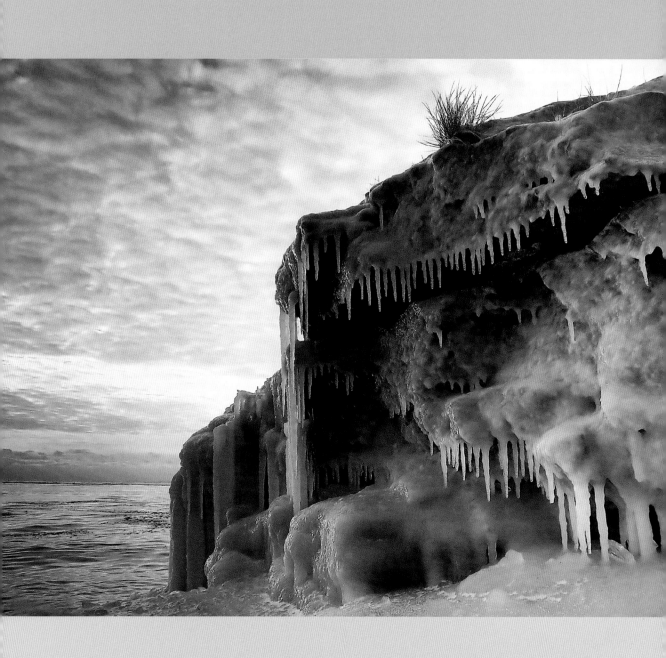

1

snowy sunrise scenes

It's certainly not an easy task, combining a perfect sunrise with mounds of pure white snow. To get them together requires a high altitude or latitude location where snow will be on the ground for some time, hopefully without being trodden on as well. The technical difficulties as well make the snowy sunrise shot a real challenge, but when it comes off, the combination of white snow and red skies is a winner.

shoot

This shot was somewhat difficult for Markos Berndt not just because of the conditions and time of morning. The place was Devil's Lake in Wisconsin, which is an area a little north of Madison, Wisconsin, USA. Markos was there two hours before sunrise to make sure he got the shot, but simply getting there was hard enough. It was still dark and he had to climb 250ft/76m cliffs while carrying a camera bag and tripod. He brought a spotlight so he could see where he was going and hopefully not fall.

The picture was shot on a Minolta consumer digital camera, with a 2 stop graduated filter to balance the exposure and keep the snow white.

enhance

The image was enhanced with curves to ensure the white was as pristine as possible (2). The saturation was increased slightly with the hue/saturation option (3).

The unsharp mask was then used to sharpen the image. It was used at 50% so that no obvious halos appeared (4).

2 **curves**

4 **unsharp mask**

enjoy

While Markos has not sold any prints of this image, it has been resized and sharpened so that it can be used on a website specialising in selling photography and art.

> digital capture
> curves
> hue/saturation
> unsharp mask
> save as TIFF
> resize for web
> save as JPEG

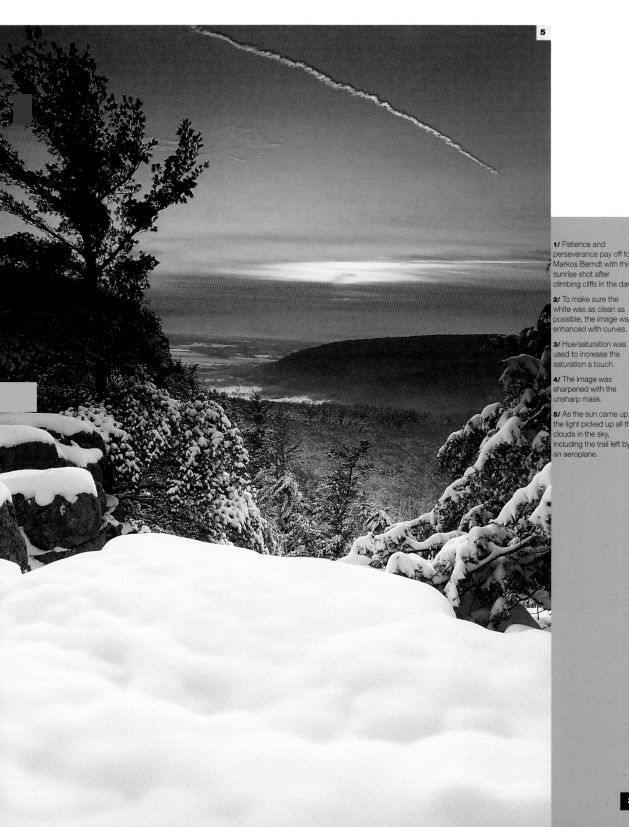

1/ Patience and perseverance pay off for Markos Berndt with this sunrise shot after climbing cliffs in the dark.

2/ To make sure the white was as clean as possible, the image was enhanced with curves.

3/ Hue/saturation was used to increase the saturation a touch.

4/ The image was sharpened with the unsharp mask.

5/ As the sun came up, the light picked up all the clouds in the sky, including the trail left by an aeroplane.

Cold conditions reduce battery life significantly so when shooting in very cold conditions, either keep the camera in a warm place, or remove the batteries and store them inside your coat to keep them warm and working.

photographing ice

There are few things as evocative of distant, icy climes as icebergs. They summon up an entire history of tall ships struggling through frozen waters, yet also bring forth the calm and glacial beauty of remote and inaccessible places at the far ends of the earth. Shooting them demands detail and that requires narrow apertures of the order of f22. Most icebergs will be shot from sea, which is a moving platform, so problems can arise. Fortunately, all the ice and snow reflect tremendous amounts of light, ensuring that there is sufficient shutter speed to avoid blurring.

shoot

Krys Bailey from Southampton, UK went on a five-day cruise trip, taking in the wonderful Patagonian fjords of southern Chile and visiting some of the enormous glaciers where they meet the ocean. The berg in the picture is one of the larger blocks of ice that had been recently calved from the Pope Pio XI glacier, which is seen in the background. The berg was probably as large as a house above the water and was made from ice tens of thousands of years old. It was photographed using a Canon consumer digital SLR with an 18–55mm Canon EFS lens, from a small lifeboat.

2 levels

enhance

First the levels were adjusted to spread the tonal range out (2), then curves was used to enhance the brightness and contrast.

The burn tool (3) was used on the sky area to add more atmosphere, then the colour levels were adjusted to enhance the turquoise colour of the ice.

Finally, the blur tool was used to smooth out some of the digital noise that had appeared in the sky as a result of the other processing (4).

> digital capture

> levels

> curves

> burn

> colour levels

> blur

> save

> resize

> sharpening

> save as JPEG

! Great quantities of snow and ice invariably lead to underexposure. Set your camera to +0.5 or +1 EV exposure compensation to correct this.

! The conditions are very likely to fool the automatic white balance into giving everything a blue cast. Set the white balance manually to a high setting. If using pictographs, then the one with sun and cloud should warm it up sufficiently.

enhance

Krys prepares her pictures for web use by setting the file dimensions (pixels) as required, the resolution to 72dpi, then sharpening the picture slightly before saving to a compressed JPEG file format. Since October 2004 she has been exhibiting her pictures on her own website. Krys has been publishing her images on various websites on the internet and has sold several photos, in electronic form, this way. Her customers include the UK Ministry of Transport, Heinemann Raintree Publications and www.mindfusion.org (Puzzlemania).

5

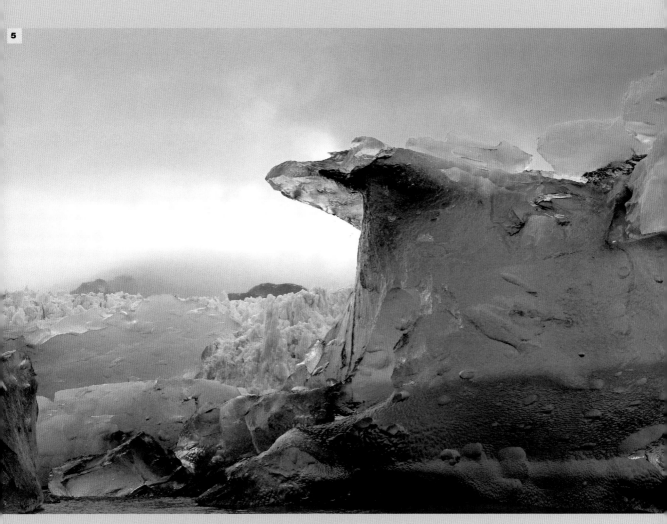

1/ Krys Bailey shot this iceberg from a small lifeboat, touring around the ice pack of southern Chile.

2/ Levels were adjusted to increase contrast.

3/ The burn tool was used to increase the colour in the sky.

4/ Finally the blur tool reduced localised noise.

5/ Krys has enhanced the blue colouring to make a dramatic study of these huge ice flows.

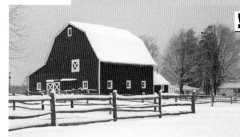

! To avoid blue or grey snow, set the digital camera white balance manually. If in doubt, try some of the higher settings.

! Look at the image in the LCD after your first shot in snowy conditions and adjust your exposure until you get nice white snow, while still avoiding blown-out areas.

1

photographing snow

Capturing a familiar building in winter can often lend it a different aspect than it would normally assume, particularly if it is commonly depicted in summer. Heather McFarland's 'Winter in the Midwest' is a prime example of this – showing a traditional barn, normally surrounded by hay and late evening, summer sunshine, but here, wreathed in snow in the midst of a chilly winter.

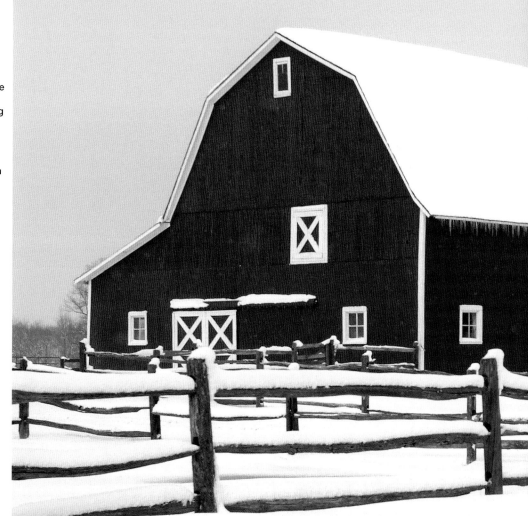

> digital capture

> crop

> curves

> print

shoot

This was taken in Metamora, Michigan, USA, which is a small rural area that has a large equine community. Heather shot the image using a Nikon professional digital SLR with a 35–70mm short telephoto lens and +0.7 exposure compensation. With beautiful fresh snow everywhere, this area was just a short drive away from the bustle of suburban Detroit and gave Heather an opportunity for some lovely winter scenes to photograph. The red barn provided a colourful contrast to all the white snow, and the fence line made for a nice composition to frame the scene.

enhance

The image required very little editing, but first of all it was cropped to remove extraneous detail on the right-hand side (2).

A curves adjustment was then used to enhance the whiteness of the snow and the overall contrast (3).

1/ This traditional American midwest red barn stands out against the snow.

2/ The image was cropped to remove unnecessary detail on the right of the image.

3/ The whiteness of the snow and the overall contrast were enhanced using curves.

4/ The white snow sparkles once it has been adjusted, making this an unusual shot of a building more commonly photographed in summer.

3 curves

enjoy

Heather has printed this image out for display in her own home and used it as a gift to family members.

4

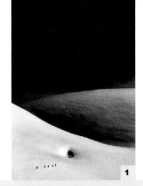

1

Concentrate on textures and form, and look for shapes. In this photo, Chris has produced an image that makes the glacier look like someone's stomach.

Always use the highest f-stop on your camera for maximum depth of field – with all the light being reflected by the snow and ice, the shutter speed shouldn't be a problem.

creating scale

When snow and ice are wrapped around familiar sights and scenes, they give a festive or pleasant aspect to the scene. Where there is nothing but snow and ice, perspective disappears and the landscape takes on an unreal or lunar aspect. If you can then find some people in that landscape, it lends it scale, without taking away the strangeness of it all.

shoot

Chris Pastella of Lausanne, Switzerland shot this photo using a Canon SLR with an 18–55mm wide-angle zoom lens. It was taken above Saas-Fee in Switzerland during one of the last touring ski days of the winter season. The view is of the glacier at about 4000m above sea level. At these heights, bright colours tend to disappear and are replaced by sharp contrasts. Chris's attention was drawn to these five little men slowly climbing upwards, having just gone past what appeared to be a huge navel in the middle of the glacier. He was attracted by the simple composition and the abstract nature of the shot.

2 crop

1/ With five small figures struggling across a vast icy landscape, the picture takes on an abstract quality.

2/ The image was cropped to improve composition.

3/ Hue/saturation was used to make the image look more desolate.

4/ Contrast was added using brightness/contrast.

5/ The final file was interpolated up to make it larger and more usable for printing and commercial use.

3 hue/saturation

enhance

First the image was cropped to a square shape as this made for a better composition and got rid of the wasted space at the top (2).

Then the image was slightly desaturated to make it look bleaker, without being pure monochrome (3).

Finally the contrast was increased slightly to give it a little more impact (4).

> digital capture
> crop
> desaturate
> contrast
> save for web
> interpolation

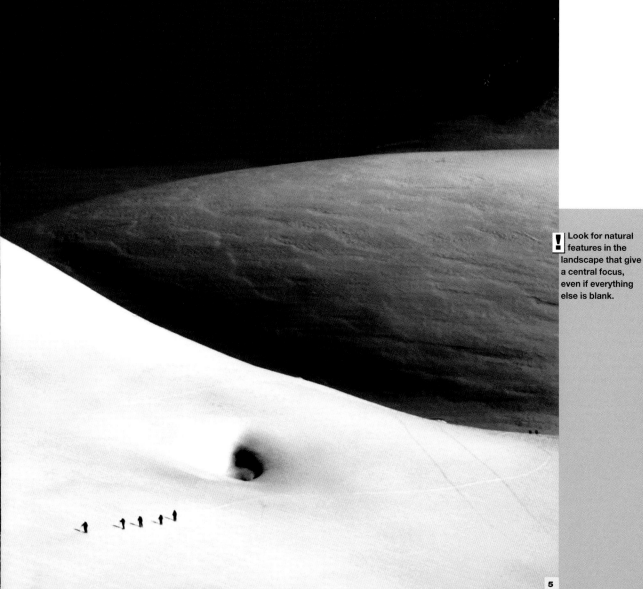

! Look for natural features in the landscape that give a central focus, even if everything else is blank.

5

4 brightness/contrast

Brightness: 0

Contrast: 20

OK

Cancel

☑ Preview

enjoy

Chris has printed the image out for his own enjoyment and prepared it for exhibition on the www.photo.net website. It was reduced to 72dpi and 700 pixels for web use.

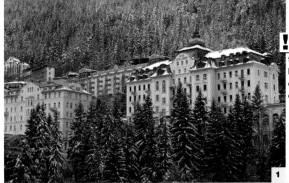

! Select manual white balance options to avoid getting either the snow in sunlight, or more likely the snow in shadow, being captured with a distinct blue cast.

visual contrasts

Take your typical forest of pine trees, add a liberal sprinkling of snow and place a large, ornate hotel building in the middle of it. And make it all happen on a steep and twisting landscape. It's an instant formula for a Christmas card-style photo opportunity. This kind of shot can be found anywhere that has pine forests and gets cold enough for regular snow during winter. The result is guaranteed to be picturesque.

shoot

Karl Baer of Menzingen, Switzerland, was staying at the Bad Gastein resort in Austria for a week in April. He had been hoping for some nice spring weather, but winter hung on tenaciously, with freezing nights and regular snowfalls. It provided an easy opportunity to shoot this scene with his Nikon professional digital SLR and Nikkor 28–70mm f3.5 AF lens.

2 levels

Channel: RGB
Input Levels: 14 1.00 220
Output Levels: 0 255

OK
Cancel
Load...
Save...
Auto
Options...
☑ Preview

! Use a wide-angle lens so that you can show the sweep of the forest and place any buildings within the panorama.

! Use a tripod and the maximum aperture (i.e. the highest f number) on your camera/lens to get the maximum depth of field.

3 curves

Channel: RGB

OK
Cancel
Load...
Save...
Smooth
Auto
Options...

Input: 128
Output: 128

☑ Preview

enhance

The levels control was used to spread the tonal range out and to make the image a little brighter (2).

Curves with an s-shape was then used to give the picture more contrast (3).

1/ Almost perfect straight out of the camera, this view of Bad Gastein in Austria is ideal Christmas card material.

2/ Levels was used to make the image brighter.

3/ To add contrast to the image, curves with an s-shape was applied.

> digital capture
> levels
> curves
> hue/saturation
> save as RGB TIFF
> CMYK conversion

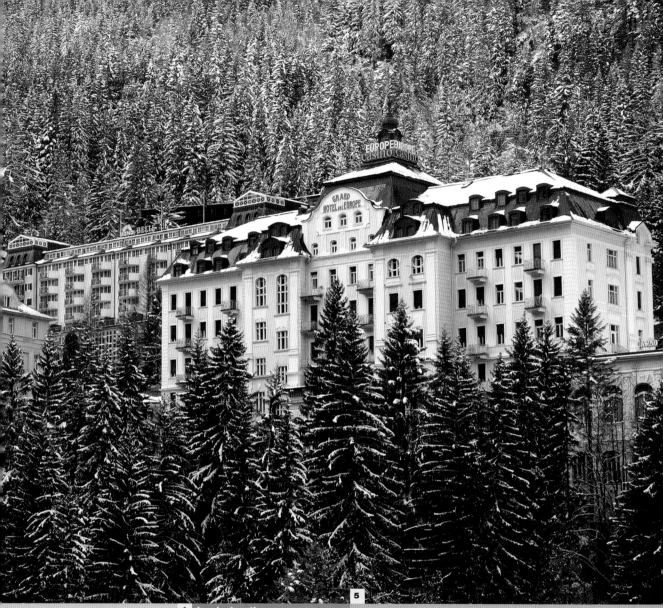

5

4 **hue/saturation**

Edit: Master

Hue: 0

Saturation: -16

Lightness: 0

OK
Cancel
Load...
Save...

Colorize
Preview

Finally, the saturation was increased by going to the hue/saturation option (4), just to put a little more colour into the building.

4/ Hue/saturation was applied to increase saturation.

5/ With a pleasing dusting of snow, who wouldn't want to spend a week in one of these hotels in the Austrian mountains?

enjoy

Up until now Karl hasn't made any prints. The final image was converted to CMYK and the colours and contrast checked before being printed in this photography book.

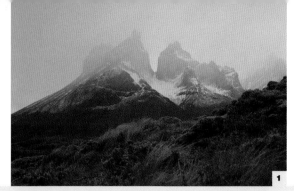
1

! Use the narrowest aperture available and focus on the mid ground rather than the distant mountain, to get the most effective depth of field.

! With white clouds and white mountain tops, consider using a graduated neutral density filter to balance out the exposure.

using the foreground

Mountains often have snow on them – the sheer altitude means that any precipitation turns to snow and the higher mountains have white peaks all year round. A more clever approach to capturing such looming landscape features, is to place the foreground in the picture, particularly if it isn't wreathed in snow, as this places the peak's height in context and gives it dramatic effect.

> digital capture
> cloning
> duplicate layer
> levels
> colour adjustment
> blur
> gradient filter
> eraser
> combine and save

shoot

The title of this picture is 'Los Cuernos' by Krys Bailey, who shot it using a Canon consumer digital SLR with a Canon 18–55mm EFS short wide-angle zoom lens. It had been Krys's ambition to photograph the famous Los Cuernos (the Horns) peaks in the Torres del Paine National Park in Chile, but when she actually arrived there the weather was typically Patagonian (wet and miserable). However, at least the peaks could just be seen through the low cloud. She took several shots and when she got home, set about trying to make something out of the best-visibility picture.

enhance

First of all some dust spots on the sensor were cloned out of the original image (2). Then a duplicate layer was created so that both sky and foreground could be treated separately.

On the foreground grass layer, the overall levels were tweaked (3) and the dodge tool was used to enhance some of the grass and flowers. The colour was then adjusted.

On the background mountains layer, the sky was smoothed out with the blur tool, the image was sharpened

2 **clone tool**

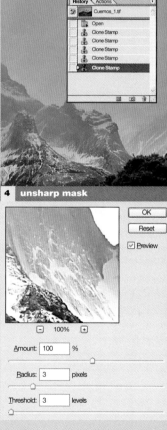

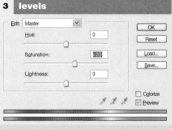
3 **levels**

4 **unsharp mask**

1/ The original digital file is flat, colourless and lacks drama.

2/ The clone tool was used to remove dust spots.

3/ Levels was tweaked on the foreground layer.

4/ Unsharp mask was used to add definition.

5/ The two layers are combined.

6/ With a gradient filter effect plus tonal and colour adjustments, the snowy mountain scene comes alive.

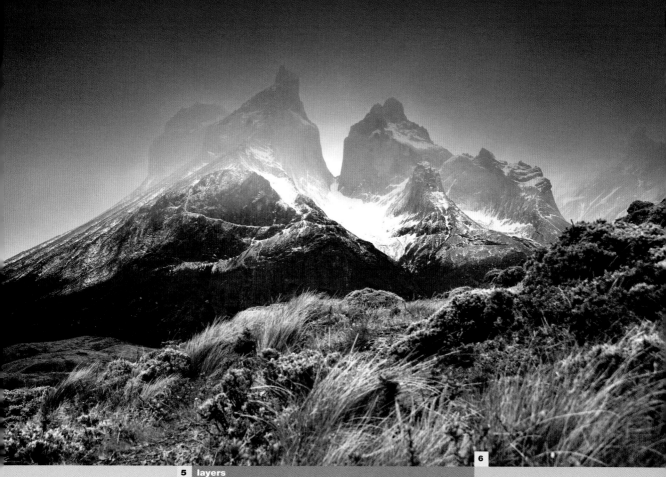

5 layers

slightly to add more definition to the rocks (4), and then a gradient filter was added to the sky to add mood and reduce any unevenness still present in the sky.

Finally, the corrected halves of the images were combined into one by erasing the part of the uppermost image that was not required, revealing the corrected image underneath (5).

! When shooting snowy scenes with zone metering, use +1 exposure compensation to counter the extra reflectivity of the snow.

6

enjoy

Krys prepares her pictures for web use by setting the file dimensions (pixels) as required, the resolution to 72dpi and then sharpening the picture slightly before saving to a compressed JPEG file format. She has been publishing her images on various websites on the internet since late November 2003, and her own since October 2004, and has sold several photos (in electronic copy) this way.

4 shooting people

Whether it's the architecture, the climate or the people around the world that interest you photographically, there is no denying that the different styles, fashion, customs and even skin colours, mean that it is the people who are the most varied. From leisure to work, industry and city life to rural, certain photographic types will identify where an image was shot as surely as a large label underneath it. For the photographer, the rich diversity of humanity is an opportunity that cannot be overlooked when travelling. In this chapter, we look at a wide range of people and the places in which they live and work.

Marco Pozzi of Liverpool, UK shot this image using a Nikon consumer digital SLR while he was travelling through India. He shot it with a 17–35mm f2.8 lens with a digital ISO rating of 200.

Marco says: 'This gentleman was serving at a restaurant when I was on my way to the village of Rishikesh in southern India. I thought he would make a fantastic subject for a portrait.'

photographers

Marco Pozzi
Mark Shapiro
Gustaf Bjerne
John Andersen
Paul Rains
Mike Hollman
Karl Facredyn
Duncan Evans
Mellik Tamás

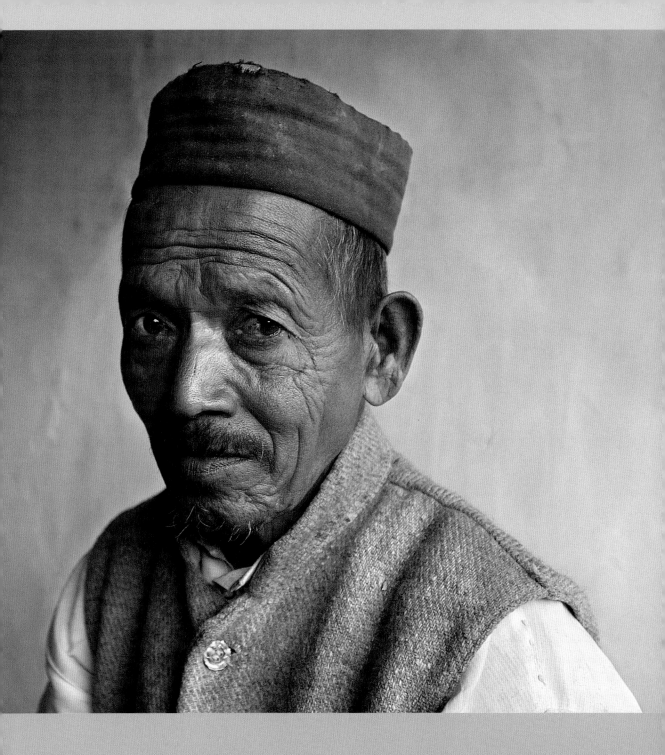

Mark Shapiro is an Australian photographer living in Vietnam. He was about 100km north of Dalat, at a place called Lak Lake, which is just a small village of the M'nong ethnic group. Arriving after a scorching hot bike ride, Mark was hoping to find somewhere nice to swim, but the lake was only ankle deep. Instead he wandered around the village and found this lady, sheltering under the awning of her long house. It took about 30 minutes of friendly chat before she allowed Mark to take her photo using his Canon consumer digital SLR with 28–135mm zoom lens. His Vietnamese is pretty average, but he managed to discover

capturing traditions

While smoking is being discouraged around the western world thanks to health concerns from both active and passive activities, in the developing or poorer world countries, it is still hugely popular. While the appeal of photographing someone with a cigarette hanging out of their mouth has largely gone, there is plenty of photographic merit in capturing someone using a traditional smoking device or pipe.

2 hue/saturation

enhance

The colour saturation was increased as this affects how the filter in the next step works (2).

The image was converted to black and white using the Photoshop plug-in called Convert to B&W Pro (3).

Then the contrast was increased using the curves function (4).

1/ Patience paid off for Mark Shapiro as he convinced this Vietnamese woman to allow him to take her photograph.

2/ Hue/saturation was used to increase colour saturation.

3/ The image was converted to black and white.

4/ Curves was used to increase contrast.

5/ Converted to black and white, the image now has much more impact and the smoke really stands out.

3 convert to b&w pro

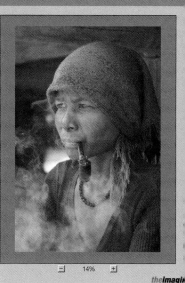

theimagi

! When recording people close up, allow them to relax before firing the shutter.

! Don't bother shooting when people pose for the camera, try to capture them looking natural.

that she was around 45 with four children. The pipe is traditional to the M'nong villages and she was smoking Vietnamese-grown tobacco.

4 curves

Channel: RGB

OK
Cancel
Load...
Save...
Smooth
Auto
Options...

Input: 82
Output: 55

Preview

enjoy

Mark has printed and sold numerous copies of this photo. It was also exhibited at the Sofitel Plaza Hotel, Hanoi, in June 2004. For use in this book the final image was converted to CMYK.

For close-up shots like this, a short telephoto zoom is all you need. Shoot with a wide open aperture to blur the background.

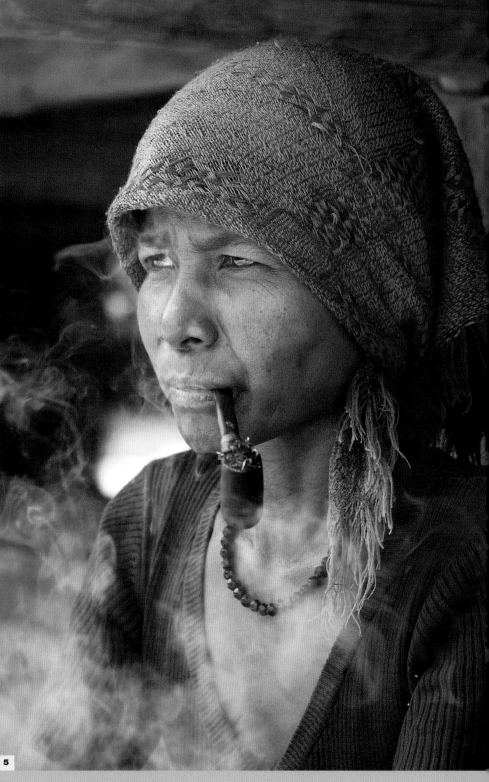

5

2 hue/saturation

Edit: Master

Hue: 0
Saturation: 20
Lightness: 0

OK
Cancel
Load...
Save...

☐ Colorize
☑ Preview

capturing the passage of time

Old folk are great photographic subjects, especially when you are abroad, as youngsters tend to favour clothes and styling of current trends. That may be traditional, but increasingly it is becoming western. The older people though will invariably be wearing more traditional dress and this gives you the opportunity to shoot portraits that reflect the passing of time in those countries.

> ! | Use a lens with a wide aperture to throw the background out of focus and concentrate on the features of the subject.

shoot

This shot was taken by Mark Shapiro, using a Canon consumer digital SLR with a Canon 50mm f1.8 lens. He had been on a motorbike trip with a friend who he had become separated from due to Mark taking too many photo stops. He ended up sleeping in a roadside loggers' hut while his friend made it to the next town about 10km away. Mark caught up with him early the next morning and while they were eating breakfast, this gentleman sat down to contemplate life and perhaps check out the two foreigners in his tiny town.

enhance

The saturation was increased by 20% using the hue/saturation slider (2). Then the curves function was run to give the image more contrast (3).

The image was then converted to monochrome using the Convert to B&W Pro plug-in by theimagingfactory created for Photoshop (4). The red colour filter was selected along with the Kodak T-Max film emulation.

3 curves

Channel: RGB

OK
Cancel
Load...
Save...
Smooth
Auto
Options...

Input: 124
Output: 131

☑ Preview

4 convert to b&w pro

☑ Pre Filter Color:
60 °
5 %

☑ Color Response: Kodak TRI-X
38 | 82 | 63 | 72 | 68 | 90 | 0
Gamma

☑ Tonal Response: Linear
Neg. Exp: 0
Exposure: 0
Multigrade: 2.0

☐ Sepia Tone Color: Tobacco
Intensity
25 %
○ Tint ● Tone

OK
Cancel
Load...
Save...

☑ Preview
R:
G:
B:
K:
D:

14%

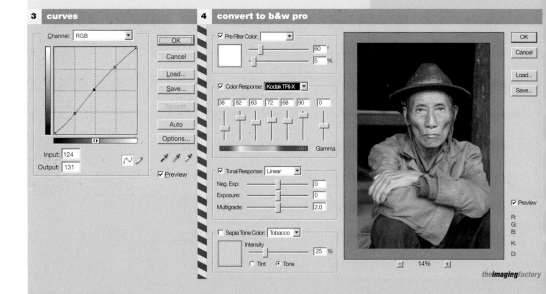

theimagingfactory

> digital capture
> saturation
> curves
> Convert to B&W Pro
> save for web

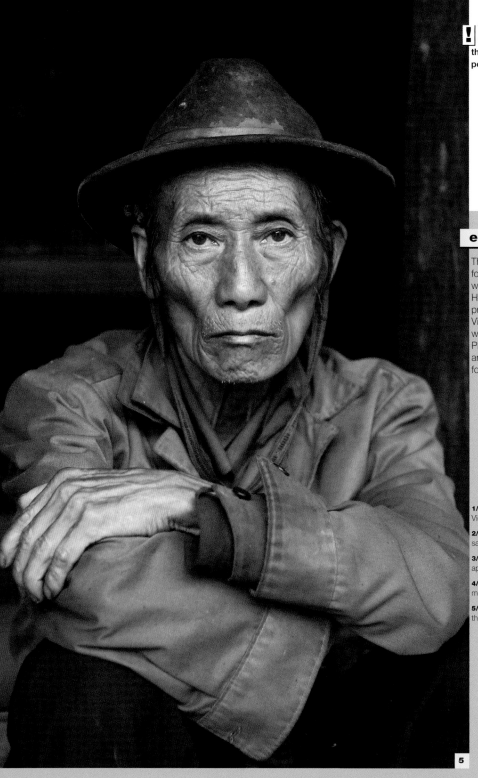

! Try to use available light to create shadows around or on the face for even more moody portrait studies.

enjoy

This image has been sold in large print format and as postcards in Hanoi. It was exhibited at the Sofitel Plaza Hotel Hanoi in August 2004 as a 40 x 60cm print and featured in Heritage, the Vietnam Airlines in-flight magazine. It was prepared for the web using Photoshop, resized to 900 x 700 pixels and exported with the Photoshop save for web option.

1/ The splendidly worn face of this man in north Vietnam makes an excellent portrait study.

2/ The hue/saturation slider was used to increase saturation by 20%.

3/ To give the image more contrast, curves was applied.

4/ The plug-in Convert to B&W Pro was used to make the image monochrome.

5/ Enhanced and converted to black and white, the subject now looks gaunt and worn by time.

5

> **!** Use a telephoto lens to pick out individual people without them being aware of the camera.

traditional activities

Fishing is a traditional economic pursuit of coastal villages and allows the photographer an excellent opportunity to combine traditional working dress with a practical, working activity. It also affords a more rare opportunity to capture people in contemplation, as they wait for the tide or the boat to come in.

shoot

This particular shot was captured by Gustaf Bjerne of Helsingborg, Sweden in the little fishing village of Yoff, just outside Dakar. He shot it on a professional Nikon film camera with a Nikon 80–200mm ED telephoto lens, and subsequently scanned it on a Canon scanner. Gustaf was waiting for the boats to come ashore when he noticed this interesting and colourful fisherman deep in thought.

2 resize

enhance

The image was scanned and loaded into Photoshop. The first step was to crop it to a more appropriate size and aspect. Then it was resized to a more usable size as the original scan was too large (2).

Levels and curves were adjusted to match the original image (3).

The corners of the image were burnt in (4), so that the eye is drawn to the man in the middle. The image was then cleaned up and dust spots were removed (5).

3 curves

> **!** Try to include either the background or the person's tools to show them engaged in their activity.

4 burn tool

5 clone stamp

> film capture
> scanning
> crop
> levels and curves
> burning in
> dust removal

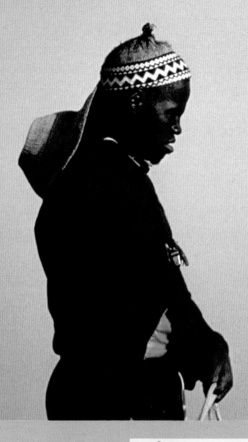

6

! Break all the rules as with this photograph, and show the subject in isolation.

1/ The original scan after film capture.

2/ After cropping, the image was resized.

3/ Levels and curves were adjusted to match the original image.

4/ The corners of the image were burnt in.

5/ The image was cleaned up with the clone stamp.

6/ The final image.

enjoy

Gustaf sells archive images through different agencies and through his own web page. He also sells fine art prints and posters. On top of that he works with magazines, writing articles about travel destinations and what is going on around the world.

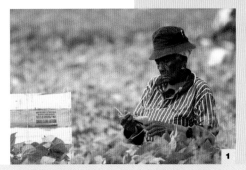

traditional activities cont.

There's no better place to find people going about their daily work in rural communities, than out in the fields. Armed with a long lens, you can comfortably capture their industry without intruding. Photograph someone undertaking a traditional or typical task for that country and you have the perfect photographic record. What you must ensure that you don't do is take pictures of people if they show any sign of being unhappy about being photographed. Remember that and you'll have a memory card full of great travel pics.

shoot

This shot was taken in south Florida, USA during the farming season. This woman was one of thousands of migrant farm workers who spend parts of their year in Florida doing the back-breaking work of picking produce. John Andersen, who lives in Miami, saw her as he was driving by the field. He snapped this one picture with his Canon consumer SLR using a Canon 100–400mm IS lens.

enhance

The image was shot in RAW mode so it needed to be developed into a 16-bit RGB TIFF file first. The saturation was increased during the process. Then, in Photoshop, the clone stamp tool was used to remove the distracting background in the upper right of the photograph (2).

The Shadow/Highlight tool was used to increase the shadow detail slightly (3).

The picture was sharpened by running the Unsharp Mask filter twice (4).

3 shadow/highlight

! Use a wide open aperture to reduce the chance of shutter speed shake.

4 unsharp mask

1/ The original snapshot of a migrant worker in a field, taken as John Andersen was driving past in his car.

2/ The clone stamp was used to remove unwanted clutter.

3/ Shadow/highlight was used to increase the shadow.

4/ Unsharp mask was run twice to sharpen the image.

5/ With a modicum of tweaking, this photo represents the back-breaking work in fields the world over.

> digital capture
> RAW conversion
> saturation increase
> shadow/highlight
> unsharp mask

! Crop in close using a long lens to isolate single figures in large, open areas.

! If your shutter speed falls below the focal length of the lens, camera shake may ensue. So, if your shutter speed falls below 1/35th when using a 35mm lens, or below 1/400th when using a 400mm lens, it may be time to increase the ISO rating.

enjoy

John prints his pictures for his own enjoyment and for his business. He sells archival digital prints frequently at fine art shows and has a portrait photography business.

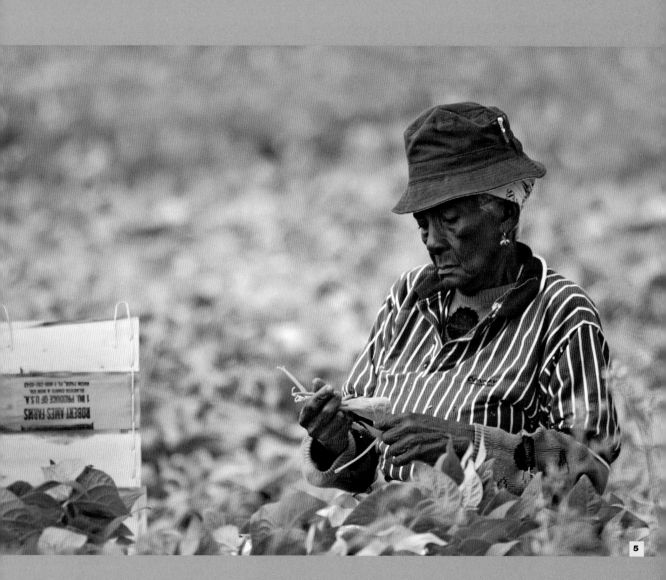

5

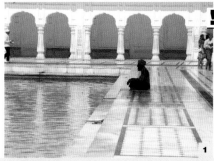

1

! At times of prayer you will catch most of the local colour entering and leaving the place of worship, but it will be prohibitive to take internal photography.

religious worship

All around the world there are various religions that offer the travelling photographer a rich seam of source material. People can be praying, in meditation, going into or coming out of a church or carrying out any other activity that is tied to their religion. Capturing people during religious worship should always be done with respect for the culture as it can be easy to offend.

shoot

Paul Rains took this picture using his Minolta DiMAGE 5Mp consumer digital with a 7x optical zoom at the Golden Temple in Punjab, India. This is the holiest place of worship in the Sikh religion in north India and Paul caught the man in the picture meditating. The zoom was almost at the end of its reach – around 200mm to get the picture.

1/ At the limit of the optical zoom, Paul Rains captured this man in deep meditation.

2/ The overall contrast and tonal range in the original image was increased using levels.

3/ The image was cropped for impact.

4/ Colour saturation was increased.

5/ The final image is a respectful record of worship at the Golden Temple in Punjab.

2 levels

Channel: RGB

Input Levels: 20 | 0.76 | 255

OK
Reset
Load...
Save...
Auto
Options...

Output Levels: 0 | 255

☑ Preview

enhance

First the levels command was used to increase the overall contrast and tonal range (2). The image was then cropped to focus in on the figure and remove wasted space and other people in the photograph (3).

The colour saturation was increased with the hue/saturation command as the camera tended to produce very neutral colours (4).

! Shoot frequently; unlike film the expense of frequent shooting is not an issue.

> digital capture
> levels
> crop
> hue/saturation
> interpolation
> CMYK

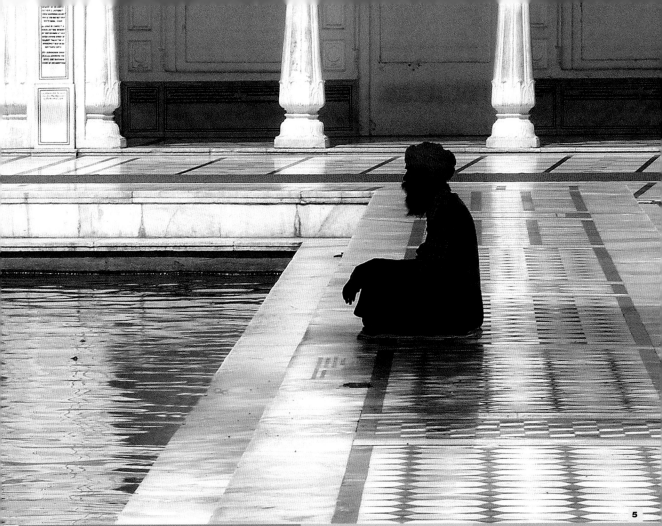

5

3 crop

! Be discreet when shooting at religious events. If your camera has a sound effect when it captures a picture, turn it off.

4 hue/saturation

Edit: Master

Hue: 0

Saturation: 20l

Lightness: 0

OK
Reset
Load...
Save...

☐ Colorize
☑ Preview

enjoy

While Paul has only printed this image out for his own enjoyment, he did submit it to us for this book, which required a further stage of interpolation to increase the file size, plus conversion to CMYK for commercial printing.

1

candid shots

Candid photography is all about capturing people going about their business without them realising that you are doing it. By dispensing with posing and the awkwardness some people and cultures feel in front of the camera, you can get to the heart of the scene, capturing the person and the emotion or atmosphere. As long as you are on public land and not shooting into a private residence with a long lens, the law gives you the right to photograph people going about their business. It is wise, however, not to abuse that, and not photograph people where the situation is personal or sensitive in nature.

shoot

Paul Rains of Ellington, Missouri, USA took this photo in a village in Punjab in north India, using a Minolta DiMAGE compact digital with a 7x optical zoom. He had just visited the potter who gave him a brief tour of his house and yard where pottery, in various stages of development, was scattered throughout. When his visit was over Paul was walking away through the yard when he saw the potter's wife walking in the yard. It was a windy day, so she had her scarf wrapped around her face to keep the dust out of her eyes. This is a common practice among women in Punjab in dusty areas.

2 levels

enhance

The levels command was used to enhance the tonal range of the image (2). The picture was then given a dramatic crop to improve its composition (3).

The hue/saturation control was used

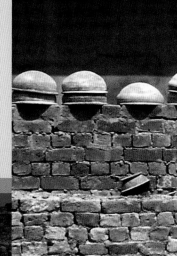

1/ Shooting from a distance enabled Paul Rains to capture this Punjabi woman going about her business.

2/ Levels was used to enhance tonal range.

3/ The image was cropped for impact.

4/ Hue/saturation were increased.

5/ Using interpolation, the image was resized.

6/ A dramatic crop now forces attention to the line of pots and the figure struggling through the dust.

3 crop

> digital capture
> levels
> crop
> hue/saturation
> remove grain
> interpolation
> CMYK

to increase saturation as the picture looked weak in its original state (4).

Finally, the grainy appearance was dealt with and then the image interpolated to a larger size (5).

enjoy

Paul produces images and prints simply for his own pleasure and hobby. He converted this image to CMYK for use in this book.

6

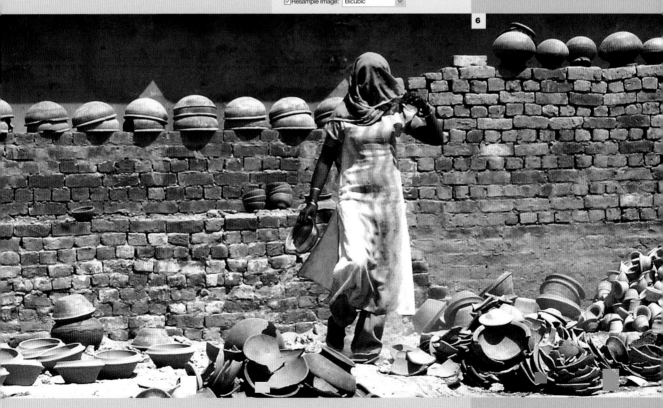

! Ensure that you are not observed taking the photo so you will usually need a long lens, unless the subject has their back to you.

candid shots cont.

Capturing people going about their business, whether it is in the city or out in the fields, brings a slice of the culture to your photography. The candid working shot should aim to be surreptitious and taken with a long lens so that the subject does not know they are being photographed and so will continue to act naturally as they go about their daily business.

shoot

This was shot by Mike Hollman of Auckland, New Zealand while on holiday in China. He had been driving through the countryside and spotted this farm. He returned later in the day to get better lighting and was lucky that there was more activity amongst the farmers. The camera, a Nikon consumer digital SLR with a Nikkor 24mm lens (36mm actual field of view), was actually on a tripod as the light was fading fast. It was shot at 1/125th of a second at f8 to get a reasonable amount of depth of field.

enhance

The levels were adjusted to counteract the effects of the lighting being very flat (2).

The colour saturation was then increased by 15% using the hue/saturation slider (3).

4

2 levels

Channel: RGB
Input Levels: 11 1.00 242
OK
Cancel
Load...
Save...
Auto
Options...
Output Levels: 0 255
☑ Preview

3 hue/saturation

Edit: Master
Hue: 0
Saturation: 15
Lightness: 0
OK
Cancel
Load...
Save...
☐ Colorize
☑ Preview

! Use a higher f-stop aperture than you would for traditional portraits so that the background to the subject is not blurred.

> digital capture
> levels
> hue/saturation
> resize
> save as JPEG

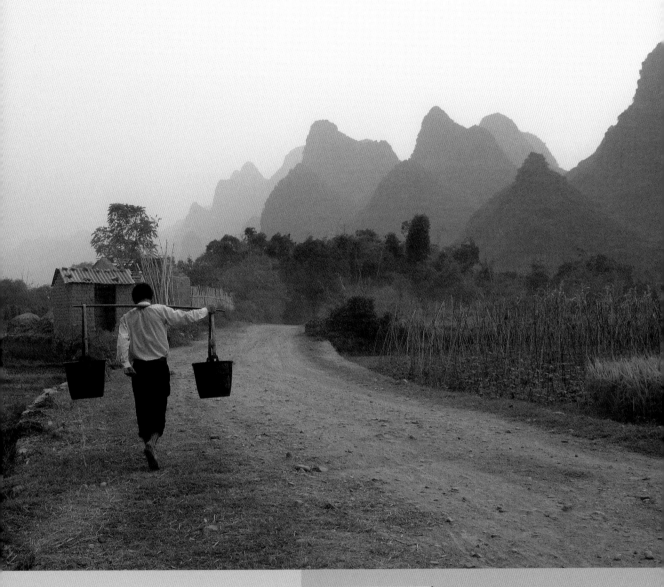

Use a wide-angle lens to place the subject within the context of their environment.

1/ Shooting this iconic shot of a rural farming scene, Mike Hollman had to make more than one visit to get the shot he wanted.

2/ As the light was quite flat, levels were adjusted to combat this.

3/ Hue/saturation was applied to increase colour saturation.

4/ The post-production work was simply a matter of tweaking the image.

enjoy

Mike doesn't really make any prints as he prefers to sell the digital images directly. He hasn't had a chance to sell this image yet. It was prepared for web by reducing the image size to a resolution of 750 x 500 pixels with some slight sharpening and saving as a JPEG in fine mode.

| | If the subject is wearing very detailed or coloured clothing, don't shoot them against an equally colourful or busy background as the result will be a mess.

| | Aim for contrasts and style. A telephoto lens will also help you blur the background with a shallow depth of field.

fashion shoots

While it might seem slightly incongruous to think of fashion while travelling, there is nothing better at highlighting the dress and lifestyle of all sections of society, from rich to poor. This can be in a setting showing off the location, or against an anonymous, but attractive background that highlights the clothes.

shoot

Karl Facredyn of New York, USA shot this dramatic image with a Canon consumer digital SLR and a Canon EF 70–200mm 2.8L telephoto lens. It had the effect of compressing the depth of field and throwing the background out of focus. So where was this location? The deserts of Namibia? The Sahara at sunset? No, it was actually shot outside a cement factory in the south of France on a windy day.

2 **hue/saturation**

Edit: Yellows

Hue: -5
Saturation: +10
Lightness: 0

OK
Reset
Load...
Save...

15°/45° 75°\105°

Colorize
Preview

3 **curves**

Channel: RGB

OK
Cancel
Load...
Save...
Smooth
Auto
Options...

Input: 68
Output: 59

Preview

4

1/ With a windy day and a billowing cape contrasting with a pure white dress, Karl Facredyn's image only needed minor tweaks.

2/ Saturation was increased using the hue/saturation slide.

3/ To add more contrast into the image, curves was adjusted.

4/ With a subtle hue shift and increased contrast and saturation, the image now really sparkles as a fashion study.

> **digital capture**

> **hue/saturation**

> **curves**

> **sRGB for web**

enhance

The hue of the background was shifted slightly to make it more orange using the hue/saturation slide and the saturation increased (2).

Curves was then used to put more contrast into the image (3).

enjoy

For the web version the image was converted to sRGB as it has a smaller colour gamut that guarantees better reproduction across a wide range of monitors. The interesting thing about this image is that it was not part of either the first or second edit for suitable images; Karl noticed it more than a year after taking it. As if with time, it gained value in his eyes when he had forgotten about the technical process of taking it.

For ambient light at night you will need to use a wide aperture like f2.8. Because of this your focusing will need to be quite accurate thanks to the reduced depth of field.

Don't just shoot on program mode when in the dark using a flashgun. Use an aperture priority mode so that the ambient light can be recorded too.

Shoot either from above the crowds for a scene shot, or get right in amongst the festival for a close up, atmosphere shot.

festivals

Attending a festival is a sure fire way of capturing the feeling, style and enthusiasm of the local population. A festival unique to that particular culture is an even better record of a place. While there are a number of famous ones around the world like the Mardis Gras, there are often lesser known, but equally distinctive festivals that will reward any photographer attending.

shoot

This is the Up Helly Aa fire festival in Lerwick, on the Shetland Islands, UK, that takes place at the end of every January. There are other Up Helly Aas around the island and the festival season stretches on until March, but the Lerwick one is the main event. Here up to two thousand people dressed as Norsemen and others in disguises arranged on a squad by squad basis, march around the darkened town, holding aloft burning torches. They drag a life-size Viking galley with them that has been built during the previous year, only for it to end up being burned to a cinder as the festival goers gather round and throw their burning torches on to it. For this shot I was stood on the roof of a garage, competing for space with the BBC Countryfile film crew. The picture was shot with a Fuji consumer digital SLR and a powerful Metz flashgun.

2 clone tool

enhance

First of all the spots of rain that showed up on the lens were cloned out using the clone tool at 100% opacity with the darken blend mode (2).

Then a Curves adjustment layer was used to darken shadows and brighten highlights (3). The mask was used to stop the bottom and ship areas from burning out.

The colours were increased using hue/saturation. The reds and yellows were specifically selected and increased by 10%.

3 curves

Layer	Channels	Paths

Normal | Opacity: 76%

Lock: | Fill: 100%

Curv...

Background

> digital capture
> cloning
> curves
> hue/saturation
> gradient
> crop
> canvas size

5 canvas size

Current Size: 17.6M
 Width: 3176 pixels
 Height: 1938 pixels

New Size: 17.7M
 Width: 4 pixels
 Height: 4 pixels
 ☑ Relative
 Anchor:

Canvas extension color: Other...

OK
Reset

A black-to-white gradient layer was added to the bottom of the picture to tone down the highlights from the flash. It was then cropped for emphasis and a border added using the canvas size command in stages.

1/ The original file showed too much light at the bottom of the picture thanks to the flash.

2/ The clone tool was used to remove spots of rain.

3/ Curves was used to darken shadows and brighten highlights.

4/ Reds and yellows were increased using hue/saturation.

5/ The canvas size command was used to create a border.

6/ This is the completed version of the fire festival picture, drawing emphasis to the figures in the boat.

enjoy

With the border added, I have printed this picture out on a Canon six-ink printer at A3 resolution. A version resized down to 500 pixels on the long side was also prepared for use on my website.

4 hue/saturation

Edit: Reds

Hue: 0

Saturation: +10

Lightness: 0

315°/345° 15°\45°

☐ Colorize
☑ Preview

OK
Reset
Load...
Save...

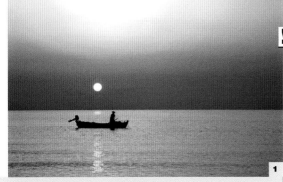

| If you can, visit a location first, so that you can see where the sun is going to rise or set and also to check out the local industry so you know who will be about at that time.

Before the sun comes up the exposure will be fairly balanced, but as soon as it rises you will need graduated neutral density filters to tone it down or the rest of the picture will be underexposed.

1

distant shots

Some pastimes and pursuits involve getting up at dawn, but for the photographer it affords a splendid opportunity to match the fantastic light with candid photography. Using a long lens you can isolate figures in the landscape, going about their activity, but framed with the incredible light that you only get at dawn or sunset.

shoot

Mellik Tamás of Budapest, Hungary, shot this picture at the resort of Messonghi on Corfu using a Fuji consumer digital SLR with a Sigma 70–200mm f2.8 EX APO HSM lens. The Fuji gives an extended focal length of 1.5x on any lens attached to it, so this gave an effective range of 300mm.

Mellik was up at dawn and as the sun came up, he spotted a local person heading out in his fishing boat. He manoeuvred into position so that as the sun rose, it appeared over the top of the boat.

1/ The original image by Mellik Tamás.

2/ The image was cropped into a square format.

3/ The saturation was increased by 20%.

4/ Dust was reduced using the dust and scratches filter.

5/ A border was added using the canvas size.

6/ The final image.

enhance

The picture was cropped into a square format, with the sun central across the image (1). The figure and horizon were therefore around the third of a way up the screen mark, following the rule of thirds for

2 crop

3 hue saturation

4 dust & scratches

composition. The saturation was then increased by 20% to make the colours stand out more (3).

The dust and scratches filter was used to reduce the amount of noise in the image (4).

After all this had been done the image was then interpolated to a larger size and a white border added using canvas size (5).

5 canvas size

> digital capture

> crop

> saturation

> dust & scratches

> interpolation

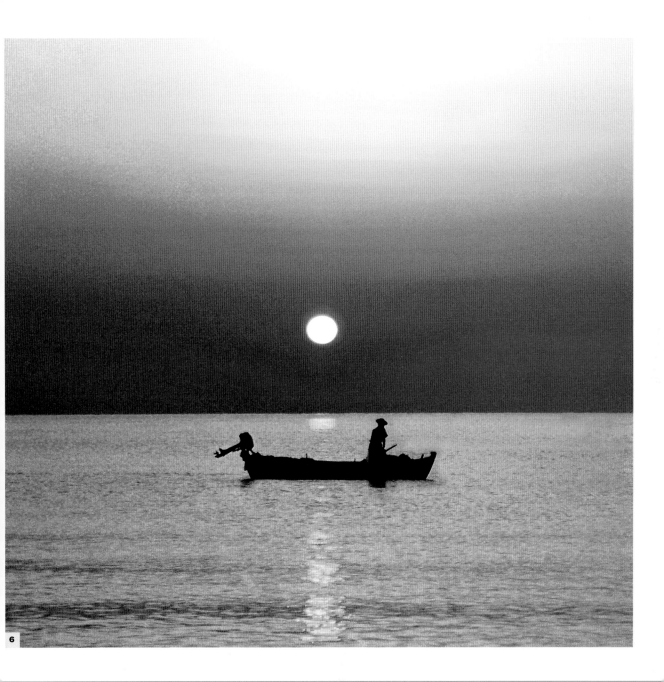

6

enjoy

Mellik has printed this image out, but as the joint owner of a small advertising agency most pictures are displayed online for clients to peruse.

He has sold images to clients and also National Geographic Books. He uses Photoshop to resize the image and then to increase the sharpness

as the process loses definition.

69

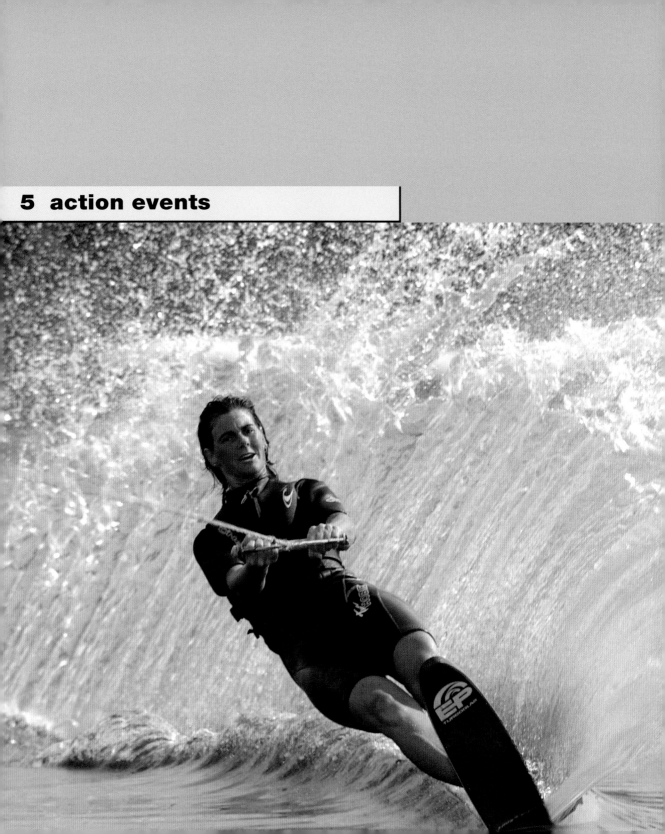

Heather McFarland of Michigan, USA, shot this
image of a water skier on Lake Charlevoix with a
Nikon professional digital SLR and a Nikkor
80–200mm telephoto lens.

Heather says: 'To capture images like this you
either need a very long lens, or do what I did –
shoot from the back of the boat that was pulling
the skier.'

There are two ways of approaching
action or sporting events in foreign
countries. Either look for an event
that is unique or heavily associated
with the country in question, or
take the opposite route and shoot
an everyday sport, but use the very
difference in facial, skin, clothes
and fashion characteristics to
highlight that this is indeed taking
place somewhere exotic. What all
event photography must do
though, is capture the excitement,
speed or passion that makes it
worth photographing in the first
place.

photographers

Heather McFarland
Lyle Gellner
Thomas Guffey
Jean-Pierre Romeyer

1

! Use a fast shutter speed of 1/1000th sec or more to freeze the action.

! To blur the background with streaks, set the camera to a speed of half a second and pan with the rider as they go past you.

cycling

Cycle races are fast enough to produce dramatic images, yet slow enough to capture without undue difficulty. They can show the strains and excitement of competition yet also portray a fine balance of man, or woman, and machine in perfect harmony. The trick in photographing them is to either get the rider pin-sharp, freezing the action dead, or to pan with the rider using a slower shutter speed, blurring the background.

shoot

Lyle Gellner was photographing this race in White Rock, British Columbia, Canada when the cyclists came round a corner towards him. He shot the picture to capture the expression on the riders' faces, using a Nikon consumer digital SLR and a 28–200mm zoom lens. The lens was right at the end of the zoom range and an aperture of f5.6 meant Lyle could generate a shutter speed of 1/2000th sec – fast enough to freeze the action dead.

2 crop

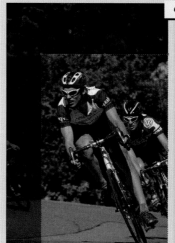

enhance

The first task was to crop the image so that the composition was tighter and closer to the action (2).

The image was then converted to black and white using the greyscale mode option.

The levels were adjusted to enhance the brightness and contrast (3). The image was then sharpened by using the unsharp mask filter with settings of 500, 0.2 and 0.0 (4). Finally, curves was used to add more contrast (5), then a border was added.

3 levels

Channel: Gray
Input Levels: 0 0.93 255

OK
Reset
Load...
Save...
Auto
Options...

Output Levels: 0 255

☑ Preview

4 unsharp mask

OK
Reset
☑ Preview

100%

Amount: 500 %

Radius: 0.2 pixels

Threshold: 0 levels

1/ In the original image Lyle was standing a little too far away to capture the action up close.

2/ The image was cropped to make it tighter.

3/ Brightness and contrast were enhanced using levels.

4/ Unsharp mask was used to sharpen the image.

5/ Curves added more contrast.

6/ With a major crop and conversion to black and white, the image now really gets to the heart of competitive cycle racing.

> **digital capture**

> **crop**

> **greyscale**

> **levels**

> **unsharp mask**

> **curves**

> **resize**

> **JPEG**

5 curves

Channel: Gray

OK
Reset
Load...
Save...
Smooth
Auto
Options...

Input: 70 %
Output: 77 %

☑ Preview

enjoy

Lyle produces prints for his own enjoyment, but has also posted this image to his website. The image was resized smaller and saved as a JPEG to keep the file size below 100k.

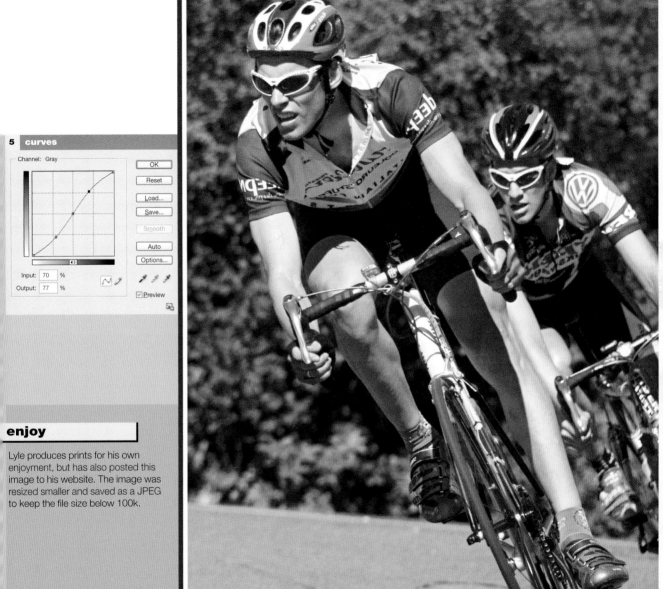

6

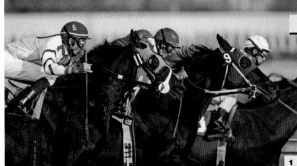

Thomas Guffey of Marysville, Washington, USA, loves the action involved in horse racing, along with the colours and the sometimes unpleasant track conditions. There is also an opportunity to photograph the human interest involved in this sport, which is always interesting. He shot this image with a Canon professional SLR with a long, fast zoom with image stabilising – a Canon 400mm f4 lens.

1

horse racing

If there's one sporting pastime that finds favour with many cultures across the world, it's horse racing. Such events give a flavour of the country that hosts them, from the pennants and markings of the riders, to the dress and activities of the punters watching at the racecourse. Use a long zoom to get in close to the action, or wander the crowds, looking for interesting candid shots.

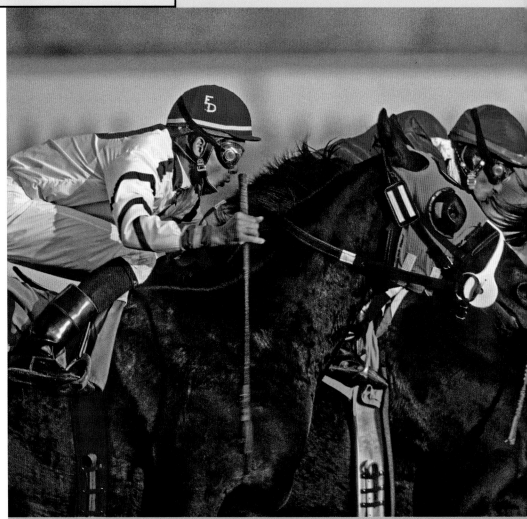

> digital capture

> crop

> tonal adjustment

> unsharp mask

> Nik Profilters

> cloning

> save for web

1/ Get close in to the action with horse racing to capture expressions.

2/ The image was cropped for impact.

3/ The image was sharpened.

4/ Dirt spots were removed with the clone tool.

5/ With punchy colours and an in-your-face crop, the excitement and energy of horse racing is revealed in the final image.

! A tripod is cumbersome to carry around a racecourse so think about using a monopod, or leaning the camera on the railings.

! A big zoom with a wide aperture is required for getting in close to the riders and freezing the action.

2 crop

! If your lens lacks the fire-power required, use a slower shutter speed to get a more surreal result, or go for crowd shots instead.

enhance

A basic crop was applied (2) to eliminate any unwanted or distracting elements in the shot.

The shadows and highlights were adjusted and the image was sharpened using the unsharp mask option (3).

Next, Nik Profilters added contrast and warmth to the overall shot. Then dirt spots were removed from the faces and bodies of the jockeys using the clone tool (4).

3 unsharp mask

OK
Reset
☑ Preview

Amount: 75 %

Radius: 3.0 pixels

Threshold: 3 levels

4 clone tool

enjoy

This specific shot has been featured on the cover of the track's publication, and was a winning shot in a sports photographic competition. To prepare for the web, Thomas reduces the size to 700 pixels along the longest side and uses the Photoshop save for web option.

> If your camera is having trouble following the action, focus on a spot where the horses are going to pass through, then switch to manual focusing.

> Use a wide aperture to get as fast a shutter speed as possible. While some blur is okay, you don't want a totally blurred picture.

1 **2**

horse riding contests

The potential for photographic images of horses being ridden increases dramatically when there is an objective or distinct purpose to the activity, rather than a frolic in the field. Add the spirit of competition, and drama is heaped upon the proceedings. Your job as photographer is to capture the moment of maximum drama, not photograph the horse cantering away at the end. To do this you must follow the action, and keep the horse and rider in focus. Some blur of movement can be very beneficial, but key elements need to be sharp and for that you need a fast shutter speed.

> **digital capture**
> **sharpness**
> **dynamic range**
> **cropping**
> **hue/saturation**
> **selective colours**
> **contrast**
> **brightness**
> **frame**
> **save for web**

shoot

The wife of Jean-Pierre Romeyer is fond of American wild west-style riding, so when a show offering a contest of these kind of skills came to Cellieu, outside Lyson in France, he took his wife and camera along for the day. The shot shows a typical pose that is called a slide stop, whereby the horse is ridden at full speed until the rider suddenly orders the horse to stop immediately. The horse should sit down on its back legs and slide on the sandy ground. To get one good shot Jean-Pierre had the autofocus on his Nikon digital SLR set to track the subject and used the three-shots-per-second burst mode to guarantee getting one good shot.

enhance

The first step was to improve the direct output of the camera through Nikon Capture 4.0 (2). Images from the Nikon digital SLR are generally soft and underexposed, so sharpness was improved and the option to enhance the dynamic range was chosen.

The image was then loaded into Photoshop. It was cropped to offset unwanted elements such as a barrel on the left (3) and to emphasise the impact of the horse running out of the picture.

The colour saturation was increased by 15% (4) and the selective colours option used to put more contrast into the cyan and white colours so that the clouds would stand out more.

3 crop

File Edit Image Layer Select Filter View Window

4 hue/saturation

Edit: Master

Hue: 0
Saturation: 15
Lightness: 0

OK
Reset
Load...
Save...

Colorize
Preview

5 brightness/contrast

Brightness: 4
Contrast: 10

OK
Cancel
Preview

The contrast was increased by 10%, the brightness by 4% and some sharpness applied (5). Finally a white-black-white frame was added around the image along with a caption at the bottom.

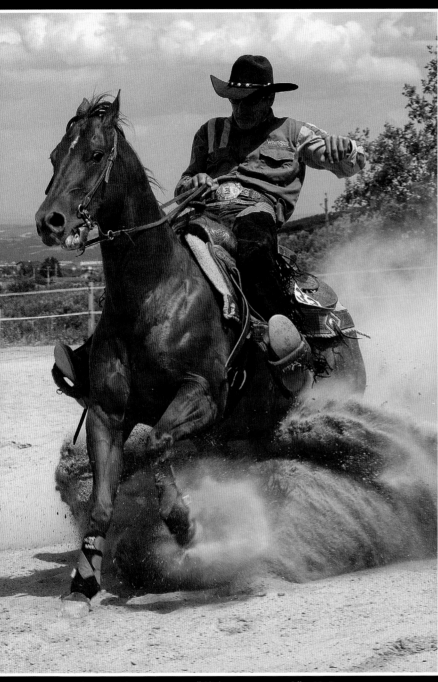

American horse riding contest - "Slide stop - part 3" - JP Romeyer

6

enjoy

Up until now Jean-Pierre has only made prints for his own enjoyment, except for a private exhibition some 25 years ago. However, since he discovered digital photography and the freedom it gives to creativity, he has become enthused to improve his work and be able to participate in an exhibition. For web use, he just reduced the size of the picture appropriately and used the Photoshop option, save for web.

1/ The rider stops the horse in full gallop producing a dramatic sliding motion.

2/ Nikon software adjustments.

3/ The image was cropped for better composition.

4/ Hue/saturation increases colour strength.

5/ Brightness and contrast were increased slightly.

6/ Once cropped and enhanced, this picture comes alive, successfully capturing the drama of the American west horse riding contest.

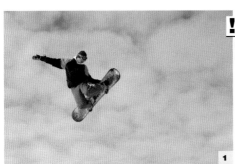

! Always ask the snowboarders for permission to take their picture. Heather usually offers prints in exchange.

! Position yourself on the underside of the biggest jumps so that the snowboarders fly over your head. Make sure they know where you are standing though.

1

snowboarding

Wherever there is snow, there will be people outside enjoying it. In the case of snowboarding you get a combination of local youth culture and high-speed downhill action event. You'll need to be quick off the mark here, but aim to capture the energy of the participants and the action of the event itself.

2 selection

febx030420rig.tif (24-Bit RGB) @ 27%- Background

enhance

Corel Photo-Paint 12 was used to edit the image. First just the snowboarder was selected as separate adjustments for the snowboarder and the background were required (2).

With the snowboarder protected, an auto equalize function was applied to the background only. This made the grey clouds white and provided more contrast to the background without blowing out the highlights (3).

Heather then used the sample/target balance tool for the highlights of the

3 auto equalize

shoot

This dramatic action shot was taken by Heather McFarland using a Nikon professional SLR with a short telephoto zoom lens. It was taken at a small ski hill in Holly, Michigan, USA. The snowboarders there were always excited to have pictures taken of them performing these high flying tricks and jumps. To freeze the action the camera was used in shutter priority mode with a speed of 1/320th second.

1/ Heather McFarland positioned herself underneath the take-off point to grab this picture.

2/ Selection in Corel Photo-Paint for editing.

3/ Auto equalize was used to make the clouds whiter.

4/ Sample/target balance tool was used to remove a reddish tint.

5/ With the background significantly edited, the snowboarder is highlighted and shown flying through the air.

> digital capture
> Corel Photo-Paint
> selection
> auto equalize
> sample/target balance
> print

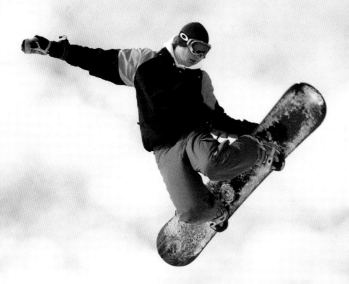

5

snowboarder to remove a reddish tint that was present (4).

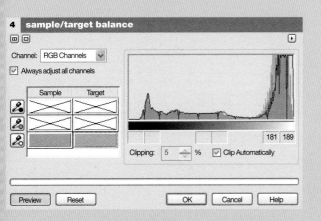

4 **sample/target balance**

Channel: RGB Channels

☑ Always adjust all channels

Sample	Target

181 189

Clipping: 5 % ☑ Clip Automatically

Preview Reset OK Cancel Help

6 animal safari

When travelling around the world, you are bound to encounter animals that are unique to the area, or at least very different from what's in your home location. Finding them in the open can be difficult, unless you are on safari with a tour guide, which makes things easier. So, don't overlook the opportunity of safari parks and zoos in foreign countries, as they will house indigenous species that you can shoot without having to spend time tracking them down. Don't overlook the opportunity of shooting sealife as well – either from a glass-bottom boat, or by taking your camera underwater.

Gavin Davies of Rhuddlan, Wales, UK shot this image with a Canon consumer digital SLR with a Canon 100–400mm IS lens. The picture required a good deal of processing to restore the saturation and light that were present on the actual day.

Gavin says: 'I was attracted to the lion in the park because I could hear it roaring. There was a monorail running nearby and every time it went past the lion would get up and roar. Then it would settle down and go to sleep again.'

photographers

Gavin Davies
Nick Biemans
Dolores Neilson
Terri Cervi
Marina Cano Trueba
Mirko Sorak

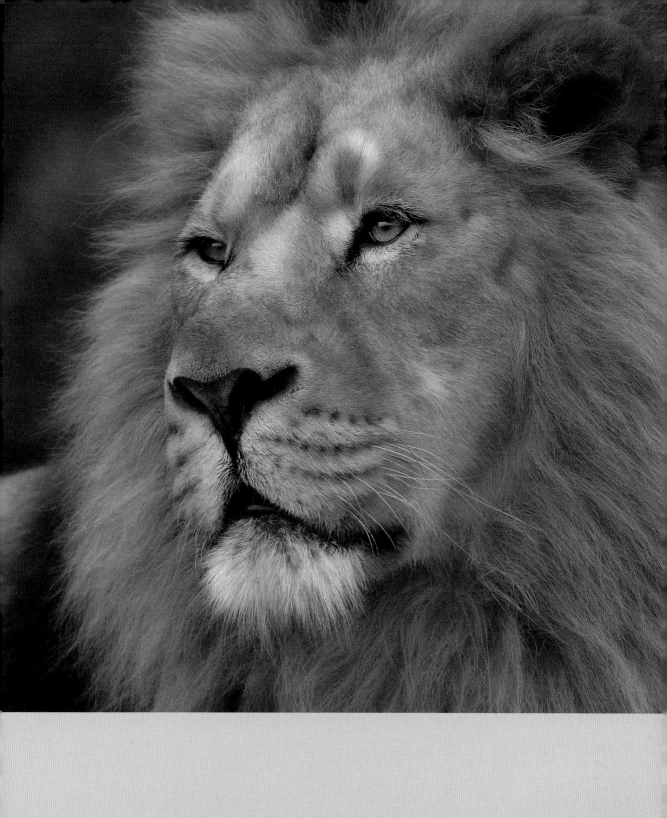

> You'll need at least a 400mm lens, which on a digital SLR will become a 600mm approximately thanks to the focal length shift.

> To avoid camera shake use this rule of thumb: Don't let the shutter speed fall below the equivalent of the focal length. Hence, if the focal length is 400mm, ensure that the shutter speed is at least 1/400th sec.

photographing large animals

Whether it's big game, or just big animals, the majesty of large animals in their natural environment is a joy to behold, and of course, to photograph. Either aim to capture the beast in the context of the surrounding, or get a close crop that shows typical or interesting behaviour. What is for certain is that you'll need a long lens to shoot from a safe distance.

shoot

Nick Biemans of the Netherlands shot this touching picture of a giraffe and her offspring with a Canon consumer digital SLR with a Canon EF 300mm f4 IS USM lens. He got extra range by adding a Canon EF 1.4 extender to push the focal length to 420mm, which combined with the Canon focal length shift multiplier of 1.6, gave an effective reach of 630mm. Nick increased the digital ISO to 200 to get a shutter speed of 1/800th sec to avoid camera shake.

2 crop

enhance

The image was shot in RAW format then converted to a TIFF for use in Photoshop. The first stage was then to crop the image to get closer, and use an upright format (2).

The patch tool was then used to remove the pole behind the foal. This was switched to the healing brush to complete the job (3).

The levels were adjusted to increase the dynamic range (4) then the brightness/contrast were increased.

3 patch tool

> digital capture
> RAW conversion
> crop
> patch tool
> healing brush
> levels
> brightness/contrast
> saturation
> shadow/highlight
> photo filter
> sharpening

4 levels

5 shadow/highlight

The saturation was increased and the shadow/highlight filter was used at 4% to give it more depth (5). Finally the photo filter was used to warm the image up. The image size was increased before a final sharpening process was applied.

1/ Bad lighting and the animals were too far away, but fortunately digital imaging came to the rescue.

2/ The image was cropped to create more impact.

3/ The patch tool was used to remove the pole in the background.

4/ The dynamic range was increased in levels.

5/ The shadow/highlight filter was used at 4% to give more depth.

6/ The photo filter was used to create warmth.

7/ With a tight crop and increased brightness and saturation, the tender moment between mother and offspring is revealed.

enjoy

Nick shoots in Canon's RAW format, so he has almost full control during the conversion to TIFF. The options he chooses depend on what the photo is needed for. For the web he uses sRGB and for print, Adobe RGB. Most of the time the pictures are for his own use. Nick places the good ones on the internet and sometimes people ask if they may use them or offer Nick an assignment.

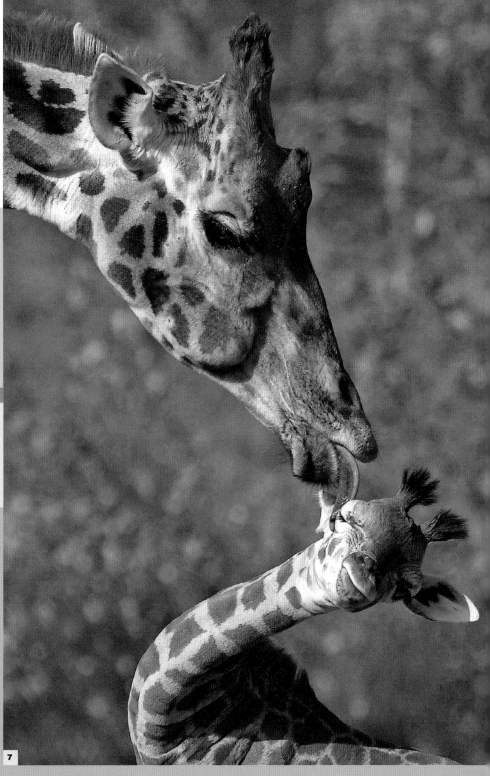

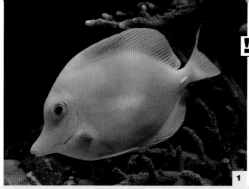

> Increase the digital ISO rather than use the built-in flash, as the result of using the latter will ruin the picture.

> Ensure that the waterproof casing is warranted for the depth you will be shooting at and always have your camera insured before taking it underwater.

1

shooting through or under water

The oceans and seas are teeming with life, so get out there and record it. You can go sailing in special glass-bottom boats that allow you to shoot through and into the water, or buy inexpensive waterproof housings for your camera and shoot from underwater yourself. From coral, to small fish, to sharks and whales, there's another world waiting for you to capture it with a camera.

shoot

Dolores Neilson of Bethany, USA shot this image of a Yellow Sailfin Tang using a Canon consumer digital camera with the Adobe RGB1998 colour space for the widest colour gamut. The fish is also known as the Yellow Hawaiian Tang or the Yellow Surgeonfish. It has an oval shaped, bright yellow body and is one of the most popular marine fish, from Hawaii to Indonesia and the Great Barrier Reef. In its natural habitat, the Yellow Tang grazes on algae and small invertebrates. It swims alone or in pairs and protects its territory by being aggressive towards other fish.

> When shooting underwater, use manual focusing as the autofocus will struggle.

2 **clone stamp**

enhance

After conversion from RAW, the next step was to remove blemishes and imperfections by using the clone stamp tool (2).

A duplicate layer was created to use levels on as the image was so dim. The lasso selection tool was used to mark an area between the tail area and body to stop it becoming too contrasty (3). The two coral extensions that frame the fish above were cloned out as they were distracting (4).

The final stage was to sharpen the image using unsharp mask. The parameters were set to amount: 195%, radius: 0.3 pixels, and threshold: 2 levels. After sharpening, any pixelation caused was cloned out.

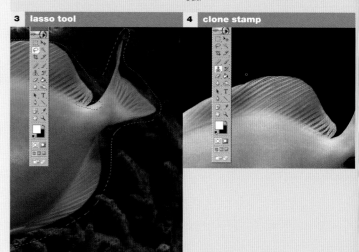

3 **lasso tool**

4 **clone stamp**

> digital capture

> RAW conversion

> clone stamp

> levels

> lasso

> clone stamp

> unsharp mask

> save for web

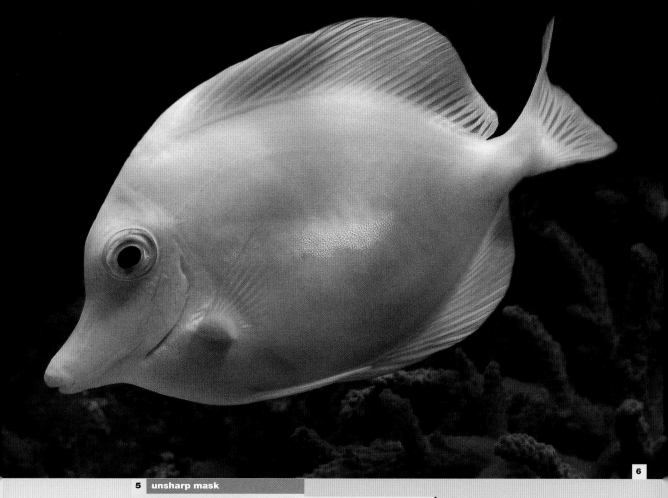

5 unsharp mask

OK

Reset

☑ Preview

☐ 13% ☐

Amount: 195 %

Radius: 0.3 pixels

Threshold: 2 levels

1/ The original image was shot in RAW format. Here it has been converted to a TIFF for processing.

2/ The clone stamp tool was used to remove blemishes.

3/ The lasso tool was used to select an area.

4/ Some coral was cloned out.

5/ The image was sharpened using unsharp mask.

6/ With all the distractions cloned out and the levels significantly adjusted, the full beauty of the Yellow Tang fish is revealed.

enjoy

The picture of the Yellow Tang has not been made available for sale yet, but Dolores has sold other images from her website, resulting in being able to afford to upgrade her camera equipment. To display on her website, the image was prepared with the Photoshop save for web option. Dolores clicks on the two-up tab to see the picture and result, then adjusts the quality as required. The low-res version is saved as a separate JPEG file.

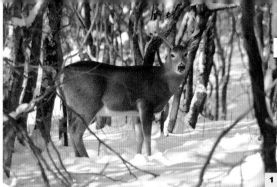

! Take the longest lens you have with you and tread carefully!

! Light coming through the trees can make a huge difference to the outcome of your image. Early morning or late evening sunlight can make an average image outstanding.

1

woodland adventure

Many countries have dense, dark woodland, and here you can find all manner of creatures, from small to quite large. Deer are a common sight and in some countries, where the woodland stretches for hundreds of miles, you can also find bears. Certainly, the larger animals make for exciting and dramatic photos, though obviously more caution needs to be taken.

shoot

Terry Cervi of Kenmore, New York, USA was hiking through the Losson Nature Trails in Cheektowaga with the intention of catching sight of deer, particularly buck. She was lucky to come across this fabulous animal, which stopped to look at her. Out came the Canon consumer digital SLR with a Canon EF 75–300mm f4–f5.6 IS USM lens and she managed to capture the moment perfectly.

1/ This image of a fearless buck was captured while out hiking down trails in dense woodland.

2/ The dark image enhance mode was selected to lighten the image and increase contrast and sharpness.

3/ The image was cropped and then resized.

4/ After a few tweaks, Terry Cervi has produced a fantastic picture of a buck deep in the woods.

2 **intellihancepro 4 filter** **4**

3 **crop**

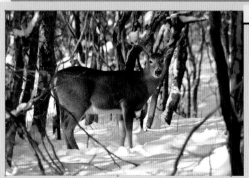

enhance

The image was loaded into Photoshop and the IntellihancePro 4 filter selected. The dark image enhance mode was selected to lighten it up and provide better contrast and sharpness (2).

The image was then cropped slightly and resized to 300dpi before saving as a TIFF file (3).

> digital capture
> IntellihancePro 4 filter
> crop
> resize to 300dpi
> save as TIFF
> Professional Image Optimizer

Compose well. The classic rule of thirds that applies to landscapes is just as valid when capturing wildlife in your compositions.

Terry occasionally makes prints for her own enjoyment or to give as gifts. She makes prints for sale, if asked, and also for photo competitions where prints, as opposed to digital files, are requested. To prepare images for web use, Terry uses xat.com Professional Image Optimizer to resize the image to 640 x 480, while still maintaining the quality of the larger TIFF file.

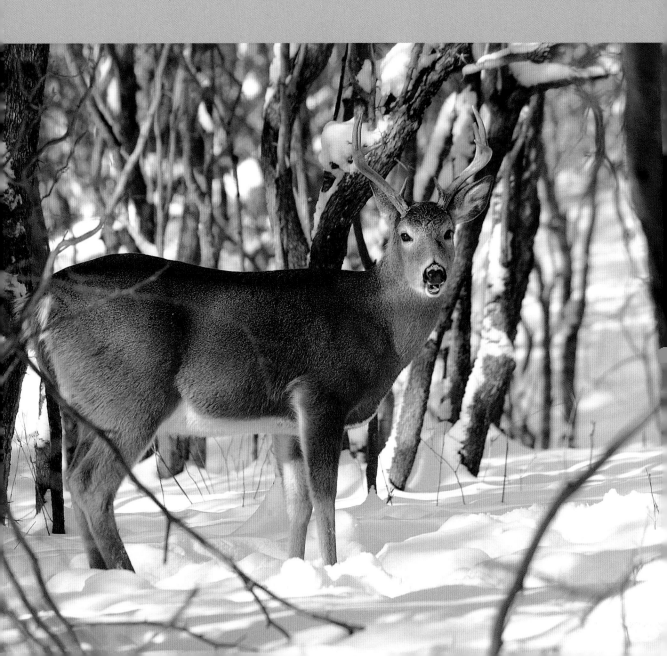

1

! If shooting out of a car, roll down the window and rest your camera on the door frame to help prevent camera shake on dull days.

removing background elements

Many countries have them and they make an animal-friendly alternative to prison-like zoos. The safari park offers wide open spaces for animals to roam, particularly large ones. For the photographer it is an opportunity to capture such beasts in more natural environments without the handicap of shooting over or through fences. The animals themselves are more at ease and exhibit more natural behaviour, which is reflected in the photographs.

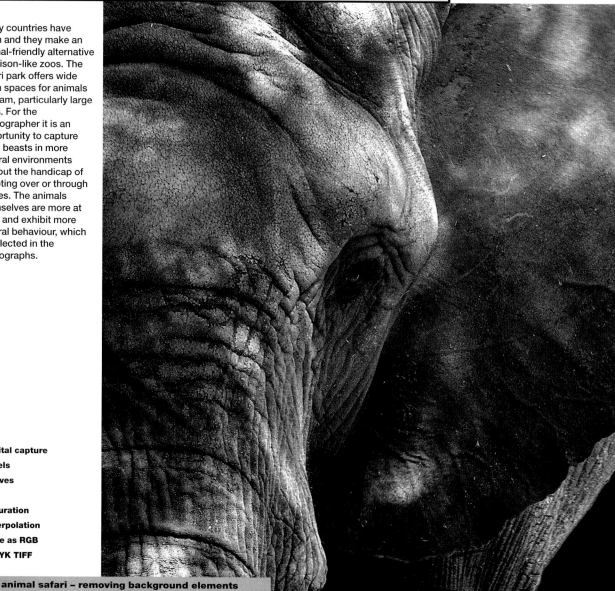

> digital capture

> levels

> curves

> fill

> saturation

> interpolation

> save as RGB

> CMYK TIFF

Bring a zoom along, as you are likely to be some distance from the animals.

If the sun is shining, include more of the background, but when it is dull and drab concentrate on filling the frame with the animal.

3 levels

shoot

Marina Cano Trueba of Santander, Spain, shot this image of an African elephant with a Minolta digital compact camera, just outside Madrid. The camera has a 7x optical zoom that allowed Marina to get a close-up shot of the light being cast across the face of the elephant, from trees overhead. The elephant was returning from drinking at a pool of water.

1/ The original image lacked contrast, though was well framed thanks to the optical zoom of the camera.

2/ With contrast and saturation adjustments the image now has far more punch and offers a startling portrait of the mighty African elephant.

3/ The levels control was used to spread the tonal range out.

4/ Curves gave the image darker shadows and brighter highlights.

5/ Hue/saturation was used to increase saturation.

enhance

The first step was to use the levels control to spread the tonal range out. As the mid-tone control carat wasn't altered, it made the image darker (3).

The curves function was then used to give the image more impact with darker shadows and brighter highlights. This caused the water to burn out, but the intention was to lose it anyway (4).

The water area was filled in with black and the saturation increased to give it a little more colour (5). Finally, the completed image was increased in size through interpolation.

5 hue/saturation

enjoy

Marina has made prints of the elephant photo, but only for her own enjoyment. For use in this book the image was converted to CMYK and saved as a high-resolution TIFF file.

Zagreb Zoo in Croatia was the setting for this shot by Mirko Sorak. He shot it with a Canon EOS digital SLR and a Sigma 24–70mm short telephoto lens. By waiting until the big cat yawned, exposing its massive teeth, Mirko captured the essence of the animal.

getting close up

Whatever the politics of keeping animals in zoos, or the more animal-friendly safari parks, vastly more people will see exotic animals there than in the wild. Of course, when travelling, a foreign zoo is often an ideal stopping-off point for viewing a wide variety of indigenous animals all in one go. The key technique when photographing them is to avoid any signs of captivity. Cages, fences or environment anomalies like concrete enclosures are all tell-tale signs that will ruin an animal shot. Close cropping compositions and wide open apertures will obscure such details, giving you the naturalistic result desired, without having to spend days in the bush.

! Avoid capturing any sign of enclosure or captivity in the shot.

2 | image size

Pixel Dimensions: 66.7M

Width: 5120 pixels
Height: 3413 pixels

Document Size:

Width: 43.35 cm
Height: 28.9 cm
Resolution: 300 pixels/inch

☑ Scale Styles
☑ Constrain Proportions
☑ Resample Image: Bicubic

OK
Reset
Auto...

3 | hue/saturation

Edit: Master

Hue: 0
Saturation: 20
Lightness: 0

☐ Colorize
☑ Preview

OK
Reset
Load...
Save...

enhance

While shot on a 6Mp digital camera, Mirko needed a higher resolution for larger output. So, the first step was to resize the image up to 5120*3413, or 15Mp (2).

Colour and contrast were then adjusted with hue/saturation and curves (3).

1/ The original image of this big cat was shot in a zoo enclosure.

2/ The image was resized for larger output.

3/ Contrast and colour were altered using the hue/saturation option.

4/ The final image is larger for bigger commercial reproduction and has contrast and colour adjustments.

> **digital capture**
> **resize**
> **hue/saturation**
> **curves**
> **save as TIFF**

If shooting inside, check and set the white balance to get the best results before you start shooting your target.

! If shooting through a wire mesh fence, press the camera right up against it and use the maximum aperture. The result may be lower in quality, but the fence links may not be visible.

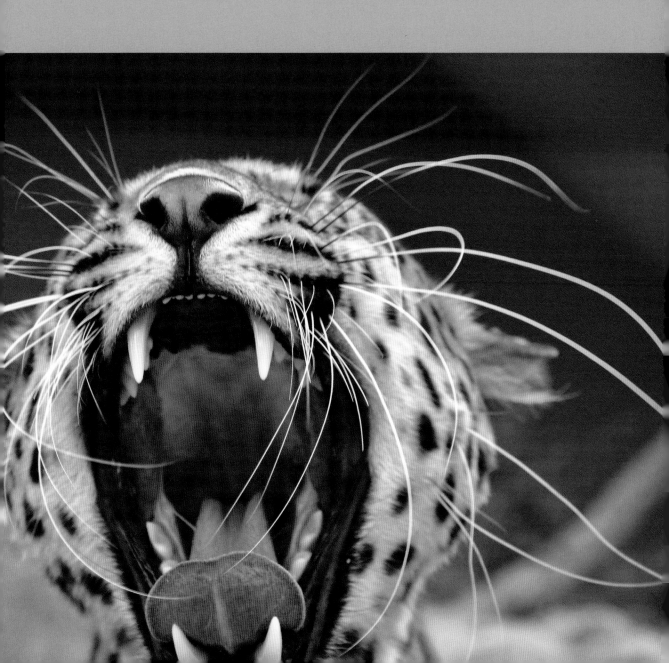

7 transportation

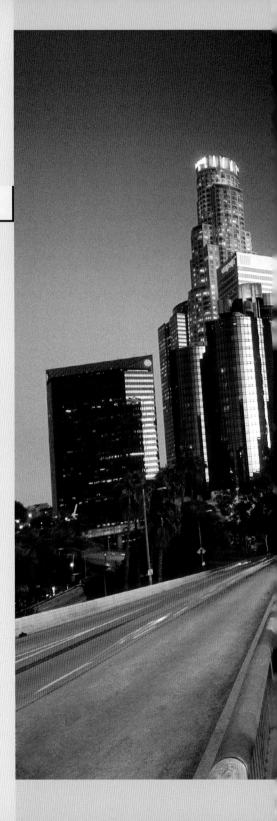

Or to put it another way, planes, trains and automobiles. Transportation, when you are abroad, can be entirely homogeneous from one country to another, or it can be area-defining. While the rural transport system is the usual lens-bait, offering a curious charm to travellers from hi-tech countries, the act of travelling is encapsulated no better than the airport: people arriving and departing, on their way to locations around the world. Embrace all these opportunities to capture the essence of the means of travel.

Anthony Arendt of Canyon Lake, California, USA shot this image with 35mm film and scanned it with a flat-bed scanner. It was cleaned up in Photoshop and the colours were enhanced and given extra saturation. The contrast was then tweaked.

Tony says: 'I live near Los Angeles and have always wanted a shot of the city at dusk. The Santa Ana winds blew the whole day, which shifts the smog out of downtown to the beach. I happened upon this frame by just driving around. The picture used a 30-second exposure, which created the energy with the traffic I was hoping for.'

photographers

Anthony Arendt
Heather McFarland
Nancy Grace Chen
Rod Edwards
Les McLean
Mark Shapiro
Mary-Ella Keith

! Digital isn't like film, and flat lighting tends to produce weaker colours. Use hue/saturation and curves to bring out the colours and contrast in old cars.

! On overcast days, undercover, try altering the white balance to give a warmer result.

exploiting the seasons

In these days of global marketplaces, you are just as likely to see a mass consumer vehicle in any country in Europe, America or Asia. However, turn back the clock 50 years or more and cars would be fairly unique to the country they appeared in. Finding such a car in good condition isn't hard thanks to classic car shows, but such collectors could have sourced the vehicle from anywhere. If you can get a local example, then endeavour to shoot it outside, and if you come across an old vehicle, lost and forgotten in some pasture, then your luck really is in.

> digital capture
> rotate
> crop
> cloning
> curves
> save
> resize for web
> sharpen
> save as JPEG

shoot

Heather McFarland of Michigan, USA noticed this old car some time ago while cruising the back roads near her home. She had been waiting for a good time to shoot it and thought that autumn would be the perfect backdrop, as there were many maple trees surrounding it. She went back when the autumn colours were at their strongest, on an overcast morning and was delighted to find that the colourful tree branches were draped over the top of the car. She shot it with a Nikon professional SLR with a Nikkor 80–200mm telephoto lens.

2 rotate image

1/ Heather McFarland had seen this rusting old car many times, but waited for the autumn season colours before shooting it.

2/ The image was rotated slightly so the car was straight.

enhance

As this was a hand-held shot, it was slightly uneven so first of all it was rotated so that the car itself was straight (2).

The image was then cropped to get rid of distractions on the left side of the picture and to remove excess image from the bottom (3).

There were some distracting elements sitting on top of the truck and in front of the rear wheel, so

3 crop

3/ Distracting elements were removed by cropping the image.

4/ The clone stamp was used to introduce more leaves and grass.

5/ Curves was used for a slight tone adjustment.

6/ With a minor tweak, some cloning and cropping, the resulting image was good enough for Heather McFarland's wall.

4 clone stamp

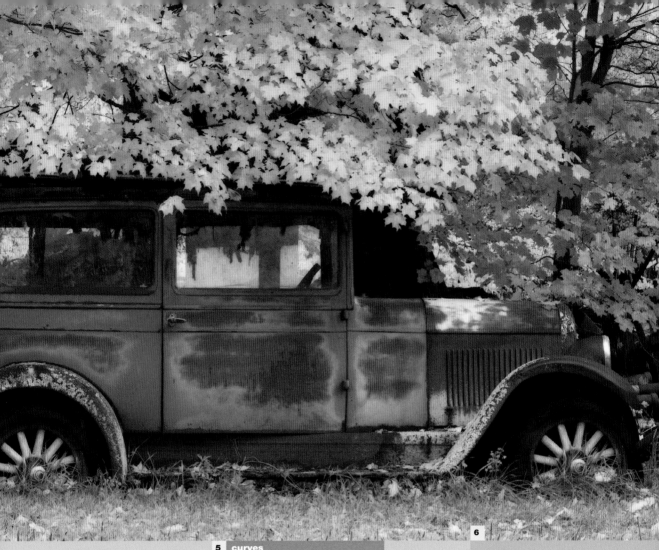

6

these were cloned out using elements that already existed in the image like leaves and grass (4).

The last step was to do a slight tone curve adjustment (5). Not much colour or contrast adjustment was needed as the soft, even morning light was perfect.

5 curves

Channel: Red

Input: 70
Output: 54

OK
Reset
Load...
Save...
Smooth
Auto
Options...

☑ Preview

! For shooting subjects that are under trees, it is better to wait for an overcast day to avoid distracting shadows.

enjoy

Heather gave a copy of the print to the owner of the car and has one hanging on her wall. It was her favourite autumn image from last season. The image was resized for her website and sharpened.

! Use a narrow aperture so that you get a lot of depth of field. This will allow you to place the subject within its environment.

! It's important to capture the colour and texture of scenes like this, so try to shoot them in good, but indirect light.

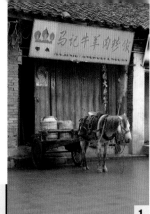

1/ By walking around the scene first, Nancy was able to compose the image to her satisfaction.

2/ To spread the tonal range out, levels was adjusted.

3/ The image was cropped to remove unwanted space.

4/ Curves was used to add contrast.

5/ The lasso tool was used to select an area.

6/ Unsharp mask was used to sharpen the image.

7/ With a few tonal tweaks and a crop, the result is a classic study of an ancient method of transport.

traditional

The sight of a horse and cart can either hark back to pre-industrial days of a rural idyll, or illustrate the relative poverty of a place compared to more developed nations. Either way, it's a classic photo opportunity to record what may be the only affordable method of transportation for some.

shoot

Nancy Grace Chen of San Antonio, Texas, USA was on a trip to Sichuan, China, when she noticed this scene while walking down the street. She thought the combination of horse and cart, and the dilapidated restaurant captured the essence of the town. Nancy walked around the scene until she could frame the horse and cart within the confines of the restaurant, then shot it with a Canon consumer digital SLR with a Canon 28–135mm IS lens. The horse and cart were gone soon after Nancy took the photo. Later, someone who saw the photo pointed out that the sign above the restaurant actually reads 'Mr. Horse's Beef and Mutton Restaurant!'

enhance

The levels command was used to spread the tonal range out to its maximum (2).

The image was then cropped to get rid of some slack space at the bottom of the picture (3).

2 levels

Channel: RGB
Input Levels: 0 1.00 255
Output Levels: 0 255

3 crop

The curves function was then applied to darken the shadows, lighten the mid-tones a little and brighten the highlights (4).

The vertical area to the right of the horse was selected with the lasso tool, then the history brush was used

4 curves

Channel: RGB

OK
Cancel
Load...
Save...
Smooth
Auto
Preview

Input: 119
Output: 141

5 lasso tool

> digital capture
> levels
> crop
> curves
> lasso
> history brush
> unsharp mask
> save for web

Standing a good distance back and shooting using the zoom will mean that the subject is not disturbed.

6 unsharp mask

to darken it down so that the highlights were not lost (5).

The unsharp mask filter was used to sharpen the image (6) with settings of amount: 75%, radius: 2.5 pixels and threshold: 0 levels.

enjoy

Nancy usually makes prints for her own enjoyment, but she has sold a few prints to friends and online. Her other paid work consists mostly of portraits.

To prepare this image for the web, the picture was saved using the save for web feature in Photoshop.

7

Rod Edwards of the UK shot this picture of Venice gondolas using a professional Kodak full-frame, 14Mp, digital SLR and a Nikon 28–105mm zoom lens. He was in Venice to write a feature on the camera for a photographic magazine, and was loaned the camera by Kodak. The image was shot off-season in November, which is the flood season in Venice. It often makes for unusual images as the water levels are much higher at this time of year. Unfortunately, winter isn't always the best time for sunshine, so Rod needed to make full use of digital manipulation and techniques to try to come up with strong and colourful images for the feature.

creating movement

The small boats of cities surrounded by water make excellent subjects, but when you start talking about the gondolas of Venice, you really have to pull the stops out to avoid producing a picture that a million tourists have already taken. The clever trick here is that the boats are gently bobbing while the buildings stay still, so exploiting this can lead to very creative results.

enhance

The RAW image was imported into Adobe Photoshop CS using the Kodak RAW plug-in. The shadow areas of the gondolas were darkened and the blue effect in the sky was increased by using the digital graduating filter and a deep blue from the colour palette (2). The white balance was then changed to give a

2 Kodak RAW plug-in

3 Kodak RAW plug-in

much warmer and more inviting feel than was originally captured. This was chosen by selecting cloudy in the RAW software and a colour temperature of 6500K as opposed to approximately 4000K of the original capture (3).

! Experiment with digital white balance to warm up otherwise bleak and colourless scenes.

! Use a long exposure of two seconds to get the gently moving objects like boats to start to blur while retaining the background.

1/ The original file was shot in RAW format. This has been converted to a TIFF here.

2/ The blue effect in the sky was increased using the digital graduating filter.

3/ A warmer feel was created by selecting cloudy and a colour temperature of 6500K.

4/ With corrected white balance and a diffuse effect, the result is a stunning portrayal of the gondolas of Venice.

5/ This is another shot from the same sequence, but here Rod covered a Skylight filter in Vaseline to create a much more dreamy image.

> digital capture

> RAW import

> contrast and colour

> white balance

> save for web

This image was created on day one of a five-day trip to Venice for a magazine. Rod was also shooting stock images for his photo library and any personal images that caught his eye. Traditional stock travel images are usually taken in sunny conditions, so he envisaged that this would be more of a fine art piece for his own portfolio. Rod has sold this image several times as a large print to buyers from his website and it has also been used in a number of travel features written about Venice. To prepare the image for the web he used Photoshop's save for web feature. He also uses this method to save large A4 size images for emailing to clients even though a 30Mb file exceeds the recommended file size.

5

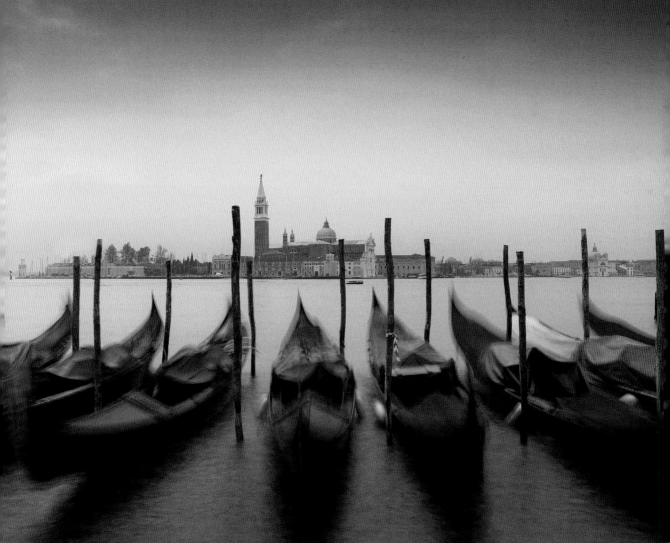

! At low light levels the automatic white balance may be fooled. Check the exposure on the LCD for either a red or a blue colour cast and go to a manual setting accordingly.

1

using reflections

While it's an old saying that a sailor has a girl in every port, the digital photographer's mantra should be that there is a memory card for every port. Ports, and specifically harbours or marinas, are a goldmine for the digital travel photographer, as they combine the luxury and opulence of sailing craft set against the backdrop of exotic architecture. That then is the key element to include in any shot of a harbour or marina – the backdrop. Evening or early mornings are the best times to shoot, which will almost certainly require the use of a tripod.

shoot

Les McLean from Otley, West Yorkshire, UK took this picture of Kalkan harbour in Turkey on a Canon digital SLR with a wide-angle lens. The exposure was 13 seconds at f22, which necessitated the use of a tripod. Les wanted a shot of this attractive harbour, and realised an evening scene would work best, particularly with the reflective lights giving a depth and perspective to the image. He waited until after the sun had set, but before it got too dark as he wanted to retain detail in the buildings. The sky, unfortunately was bland and featureless so he framed the image to exclude most of it, feeling that the sloping town buildings would provide a good enough backdrop.

! Use narrow apertures to ensure maximum depth of field and bring a tripod.

! It's easy to burn out the highlights in long exposures, so take a couple of shots, bracketing the time of exposure.

2 **levels**

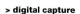

Channel: RGB
Input Levels: 0 | 0.72 | 162

OK
Reset
Load...
Save...
Auto
Options...

Output Levels: 0 | 255

☑ Preview

3 **crop**

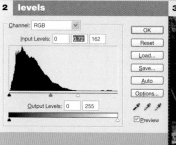

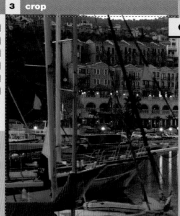

enhance

Some basic adjustments using levels and brightness/contrast were used to make the colours shine more brightly (2).

The sky to the top right was weak and washed out, so the crop tool was used to remove some of it (3).

> digital capture
> levels
> brightness/contrast
> crop
> clone stamp
> curves
> unsharp mask

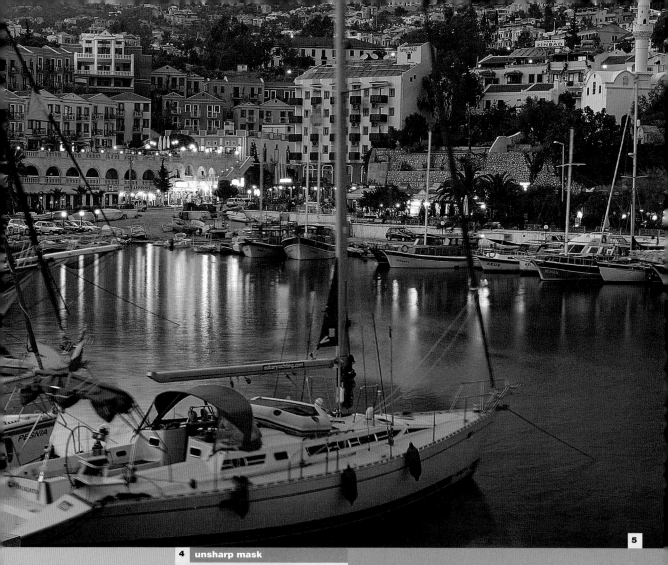

5

The clone tool was used to remove the rest of the sky and then curves were tweaked and finally, the unsharp mask option was applied to sharpen the image (4).

4 **unsharp mask**

OK

Reset

☑ Preview

⊟ 100% ⊞

Amount: 100 %

Radius: 3.0 pixels

Threshold: 10 levels

1/ The original image from the Canon digital SLR was flat and soft.

2/ Levels was used to adjust contrast.

3/ A small crop of sky was carried out.

4/ Unsharp mask was used to sharpen the image.

5/ The final image is a vibrant record of Kalkan harbour at night.

enjoy

Les has not sold or exhibited this picture, as he produced it for his own personal pleasure. To use in this book it was converted to CMYK and the colours tweaked to ensure they were true to the finished RGB version.

As the idea is one of mystery – where has the rider gone, what is going on inside – avoid having other people in the shot.

The exception to this is when you show someone going about their business on their bike. In this case do show what is going on around, but use a wider aperture to introduce a limited depth of field so that the focus can remain on the rider and bike.

avoiding clichés

All over the world, the bicycle is used as a means of cheap transportation, and not just for sport or leisure activities. The resting bicycle shot is something of a cliché, so it means that you must work harder to have it pitched against something interesting, whether through colour or content. Crop closely to avoid wasting space around the picture, but include enough of the background to frame and give contrast.

shoot

Mark Shapiro is an Australian photographer living in Vietnam. After a hard day's ride he arrived at the picturesque town of Hoi An, which is a world heritage site. He felt like a casual walk around town so opted to take his lightweight Minolta digital camera and found this scene. Although the Minolta is more than capable for a still life like this, he returned the next day with his SLR, but of course the bike was gone and the light just wasn't right.

The first rule of photography – always have your camera with you when going to new, interesting places. Opportunities may not repeat themselves as Mark Shapiro found out with this image.

enhance

The image was slightly skewed thanks to the shot being hand-held. As such it was straightened using the rotate canvas and measure tool to line up the top of the windowsill (2).

The saturation was increased by 20% to make it more vivid than it was at the time of capturing the image (3).

2 rotate canvas

Angle: 0.69 °CW / °CCW OK Cancel

An s-curve was then used to increase the contrast throughout the image (4).

3 hue/saturation

Edit: Master
Hue: 0
Saturation: 20
Lightness: 0

OK Cancel Load... Save...
Colorize Preview

4 curves

Channel: RGB

OK Cancel Load... Save... Smooth Auto Options...

Input: 66
Output: 55

Preview

> digital capture
> rotate canvas
> saturation
> curves
> save as TIFF
> sRGB mode
> resize
> save for web

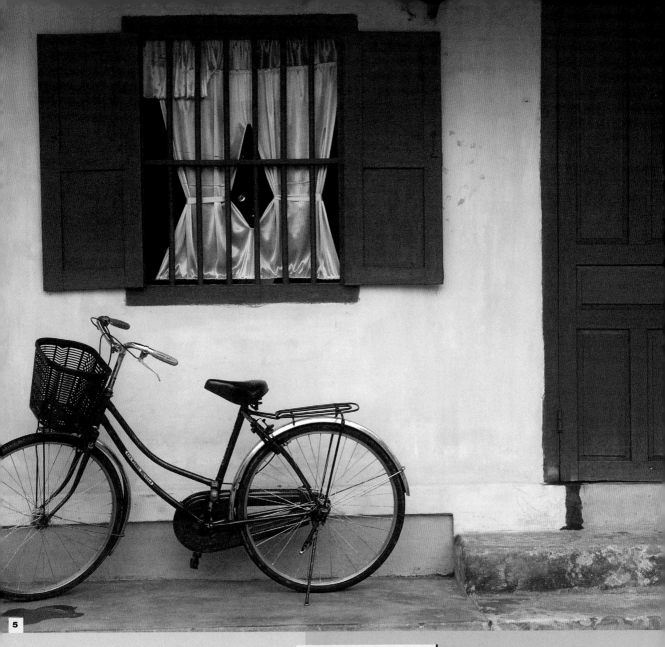

5

1/ While strolling around a world heritage town, Mark Shapiro came across this bicycle and snapped it with his Minolta compact digital.

2/ The image needed straightening using rotate canvas.

3/ Saturation was increased using hue/saturation.

4/ Contrast throughout was increased with curves.

5/ The final version of the image has stronger colours and contrast than the original.

enjoy

Mark converts images from his Minolta to the Adobe RGB colour space to accommodate the wider gamut of the camera. He makes adjustments in Photoshop then converts to sRGB only for printing or web use. This image has been sold in large print format and as postcards in Hanoi. The image was resized to 900 x 700 pixels and exported with Photoshop's save for web function.

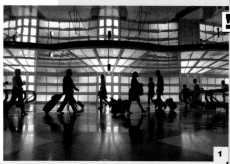

silhouettes

The airport is an essential hub in the travel process, so why not take advantage of it? The airport represents people going away on business, making personal journeys or going on holiday. It's all travel and they are all keen to be on their way. Capture this feeling of departures and arrivals with candid photography – there's no point trying to get your tripod out!

! The lighting inside airports will be subdued so use a wide open aperture or rest your camera on something solid to avoid camera shake.

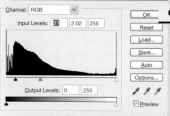

4 clone stamp

shoot

Mary-Ella Keith of San Diego, California, USA took this photo while travelling in the summer. She had to make a flight change at Chicago's O'Hare International airport. Having travelled through there before, she knew there was a unique underground concourse connecting two terminals, which was a visual extravaganza of flashing neon and wall-to-wall illuminated, coloured glass panels. She happily spent an hour or so there taking photos. For this particular image, Mary sat on the floor on one side of the long corridor, where there was a break between two pedestrian conveyors, and snapped a series of photos as travellers came and went. This one has a delightful mixture of people of all ages and types, shown in silhouette against the brightly lit panels. Mary shot it on a Canon consumer digital SLR with a Tamron 17–35mm wide-angle lens.

2 levels

3 crop

enhance

The first task was to use levels to lighten the picture (2). The image was then cropped a little to make the architectural structure as symmetrical as possible (3).

Some minor imperfections on the floor and in the glass panels were removed using the clone stamp tool (4). Finally the unsharp mask filter was used to sharpen the picture overall (5).

1/ The composition of this airport shot was fine, but the colours and contrast needed a little help.

2/ Levels was used first to lighten the picture.

3/ To keep the structure of the image as symmetrical as possible, some cropping had to be done.

4/ Blemishes were removed using the clone stamp tool.

5/ To finish up, the whole image was sharpened using the unsharp mask.

6/ Once cleaned up and enhanced, this picture from the airport in Chicago shows the excitement and bustle of travellers across the globe.

5 unsharp mask

> digital capture
> levels
> crop
> clone stamp
> unsharp mask

Mary does make prints for sale and exhibition, although not this particular image. She hopes to sell this and other similar images, and to establish herself in the field of stock photography. It wasn't until Mary went digital three years ago that she began to treat photography as a serious art medium, as challenging and vital as the oils,

watercolours, or pastels that she had used in her career as a fine artist. She now finds herself spending more and more time with photography, and less with painting, as she continues to try to master this exciting new medium.

! Neon lights will invariably cause a colour cast. Use the manual white balance setting on your camera and enter a low value to avoid this.

6

8 architecture

The architecture of a place you visit says everything about its past and who built it, and the future and where it's going. From ruins and castles, to hi-tech city skyscrapers to rustic villages and sun-bleached walls, the buildings are what define a place and represent some of the best travel imagery you can capture through the lens.

This photo was taken from an island in the middle of the Vlatava River, Prague, Czech Republic, by Michael Boyer. He had been living in Prague for several years and this was one of his favourite spots to take pictures of Old Town Prague. The light changes dramatically throughout the day and year, providing opportunities for strikingly different pictures of the same scene. Since Michael lives a short five-minute walk from the location, he looked for interesting light and weather patterns. That particular day provided dark blue/purple skies in the background, plus bright sun to illuminate the town.

Michael says: 'I remembered the day as having a dark rich bluish-purple sky. The photo as it now appeared, was much too light. I created a mask to hide everything except the sky. I then applied levels to just the sky, darkening it to the way I remembered. I then needed to apply the same effect to the reflection. In this case I created a mask for everything except the water and applied levels. The challenge was that I wanted to change the sky reflections, but not the building reflections. So, after I used levels to get the blues where I wanted them, I then used the paintbrush and slowly created a partial mask on the reflections of the buildings until they appeared to be natural.'

photographers

Michael Boyer
Karl Baer
Michael Ward
Dave Martinidez
Lyle Gellner
Duncan Evans
Jorge Coimbra
Mellik Tamás

! If you can't avoid the tourists, concentrate on one particular feature and use a wide aperture to throw everything else out of focus.

! Check the opening hours of a well-known building beforehand, then either arrive as it opens, or be in position to shoot just before closing time. This should minimise the number of tourists on site.

1

increasing contrast

By definition, a tourist magnet location is going to cause you lots of problems photographically. Firstly, it is usually full of tourists, blocking the way and obscuring the scene. And secondly, almost everyone there will have a camera, and being a place of note, it will have been visited by the professionals as well. Your task to produce a distinctive photograph is a very hard one. There are three ways you can make this your own – seek out an unusual angle to shoot from, shoot it in dramatic weather conditions or wait for fantastic lighting.

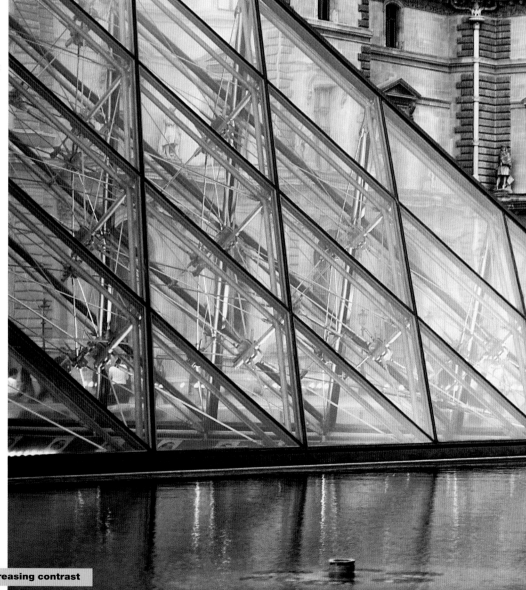

> digital capture
> curves
> hue/saturation
> colour balance
> convert to CMYK

shoot

To photograph the Louvre in Paris, Karl Baer of Menzingen in Switzerland waited until the evening when the crowds had dispersed and the artificial lighting came on, then he shot it from this unusual position, showing both the modern pyramid and the older, main museum building.

The image was shot on a Nikon professional digital SLR with a Nikkor 28–70mm f3.5 AF lens.

2 curves

enhance

The contrast was increased by using an s-shaped curve function (2). The saturation was then increased by 15% using hue/saturation (3).

Finally the colour balance was adjusted to make the image more blue and the brickwork less yellow (4).

1/ The Louvre in Paris is normally heaving with visitors, but Karl Baer waited until the evening when there were far fewer of them around.

2/ Curves was used to increase contrast.

3/ Using hue/saturation, the saturation was increased by 15%.

4/ To increase the blue colour, colour balance was adjusted.

5/ With enhanced colours and contrast, this is an unusual shot of the Louvre.

3 hue/saturation

4 colour balance

enjoy

Karl hasn't made any prints of this image, but in submitting it for this book, the embedded Adobe RGB 1998 profile was converted to CMYK for commercial printing.

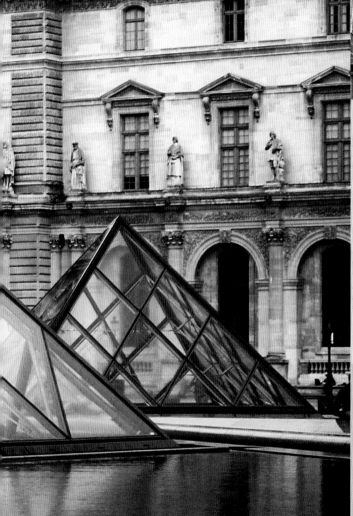

5

! In bad weather like this you will either need a tripod or have to use a higher ISO rating.

1

iconic bridges

Bridges can be as famous as the tallest building, the most well-known monument or distinctive natural feature. A classic design bridge is iconic and represents an entire area. San Francisco's Golden Gate Bridge, London's Tower Bridge and Tokyo's Rainbow Bridge – they are all representative of the cities they are based in. As such they are tourist traps and will be photographed endlessly. The challenge for you is to find an unusual angle, dramatic weather or incredible lighting, that lifts your photo out of the ordinary.

shoot

This picture was shot by Michael Ward, using a Minolta consumer digital camera, on Baker Beach in San Francisco, USA. He went to the beach to shoot some sunset pictures and because of a very recent storm, there was a particularly high tide, and the wind was brisk. Michael spent an hour shooting first out over the Pacific, then in towards the bridge then

2

4

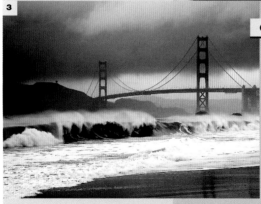

3

enhance

Firstly a smoothing filter was applied followed by selective sharpening (2).

Then a levels adjustment layer was used to balance out the exposure of the picture (3).

back towards the setting sun. It was the only picture worth keeping from that entire session.

1/ The original picture of the Golden Gate Bridge is murky because of the storm, but it captures the drama.

2/ The first step was to use the smoothing filter.

3/ Next the levels adjustment layer was used to balance out the exposure.

4/ With the unusual viewpoint and dramatic weather conditions, Michael Ward has succeeded in producing a very different picture of an iconic bridge.

> digital capture
> smoothing filter
> selective sharpening
> levels adjustment layer
> resize
> save for web

Don't be tempted to simply go for the widest aperture of f2.8 or so, to keep the shutter speed up – you will have reduced depth of field.

Compact digital cameras have much more depth of field than SLRs, so can be very useful in challenging conditions, like the ones seen in this picture.

enjoy

Michael made this picture for his own enjoyment. To prepare it for the web, he changed the colour space to sRGB, resized it to 72dpi, with the larger side set to 700 pixels, and used Photoshop's save for web tool.

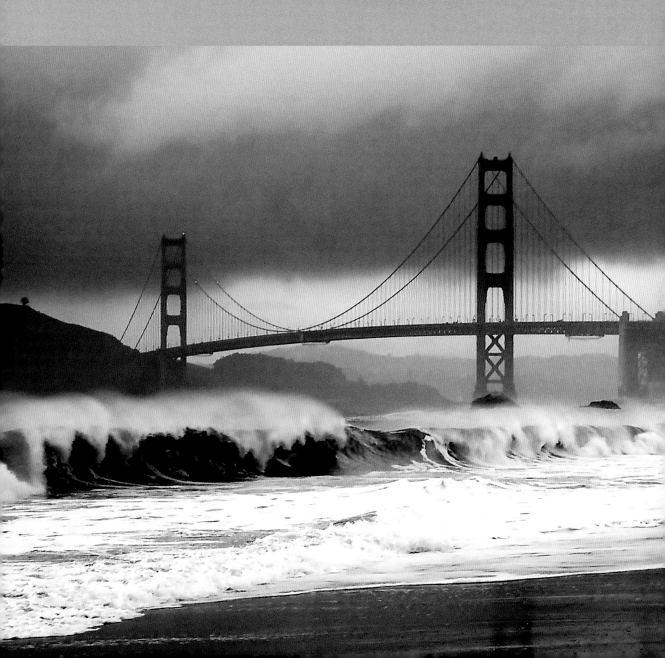

! On misty mornings try to get into position with the camera set up before the sun starts burning it away. If possible!

1

! If the weather is cold, keep your batteries in a pouch inside your coat or jacket to keep them warm, rather than in the camera sat on the tripod. Cold kills battery power very quickly.

using mist and fog

Rivers running through cities are handy generators of fog and mist on cold winter's mornings. Being in cities, somewhere along the line there will be a bridge and buildings in the background. It's an instant combination for atmospheric photography in the centre of the city. The less like tower blocks and more ornate the buildings and the bridge the better.

shoot

This photograph was taken by Michael Boyer on the Charles Bridge in Prague, Czech Republic. Michael had actually lived in Prague for three years and had tried many, many times to take this particular shot of the bridge in the fog, but with no luck, before returning to his home in the USA. It wasn't until six months after moving back to the US and returning to Prague on a business trip that the weather and light turned just right shortly after waking. He ran with a Nikon consumer digital SLR and tripod in tow to the bridge. The bridge has a constant flow of foot traffic, so getting a shot with minimum people was challenging. Within five minutes, the sun and fog had shifted and the shot was gone.

enhance

The original picture wasn't far off what Michael wanted, thanks to getting the photography right in the first place. He used the levels control and changed the input from 0 to 50 to darken the shadows (2).

2 **levels**

3 **crop**

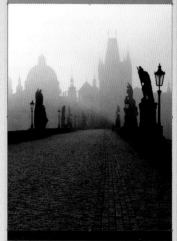

The picture was then cropped to a format suitable for printing out at 10"x8" (3).

enjoy

Michael makes prints for his own enjoyment and also for exhibiting on online competition sites. For online use, he converts the picture to sRGB for more reliable display on a variety of monitors. The picture is then resized so that the shorter side is 480 pixels and then he applies the unsharp mask filter to sharpen the photo.

> digital capture
> levels
> crop
> sRGB
> resize for web
> unsharp mask

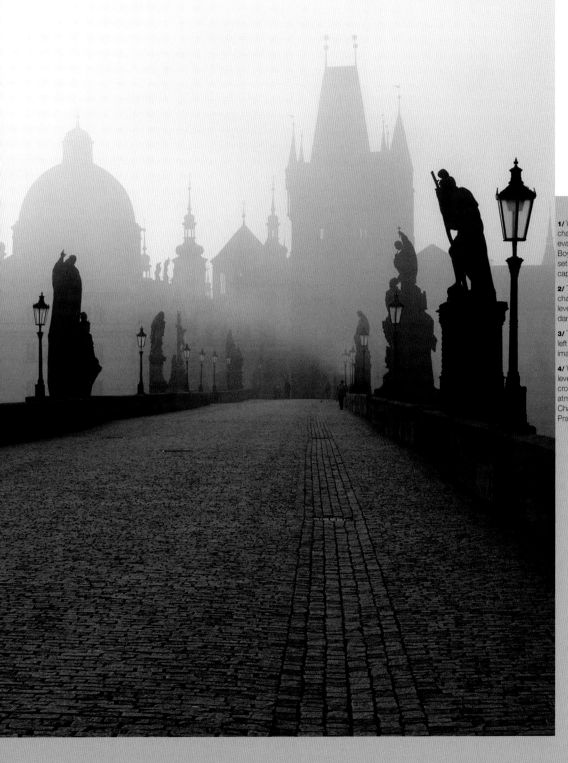

1/ With the light rapidly changing and the mist evaporating, Michael Boyer had five minutes to set up and successfully capture this picture.

2/ The input was changed to 50 in the levels control, so as to darken the shadows.

3/ The only other thing left to do was to crop the image.

4/ With a change in levels and a modest crop, here is an atmospheric shot of the Charles Bridge in Prague.

shoot

The name of this picture, by Dave Martinidez of New York, USA is 'Shine'. It is part of a series of images entitled 'Touch the Sky: New York from Below'. For Dave, it is less about the architecture and more about the interaction of these behemoth buildings with the sky. Native New Yorkers tend to forget the exhilaration visitors feel when staring straight up in midtown Manhattan. 'Shine' was shot on a high-end Canon digital compact and is an image of the Chrysler Building and

photographing skyscrapers

Modern, tightly packed cities, where the cost of land is high, feature skyscrapers. It makes economic sense to build up, maximising the footprint of the building by making it as high as possible. These days, thanks to global terrorism, skyscrapers have an added significance and poignancy. When shooting such tall buildings, the traditional architectural edict of no converging verticals goes out of the window. The direction to shoot is not sideways, but up, featuring these great buildings towering into the sky. If you can add extra buildings, reflections and an interesting sky, then you're on your way to a great picture.

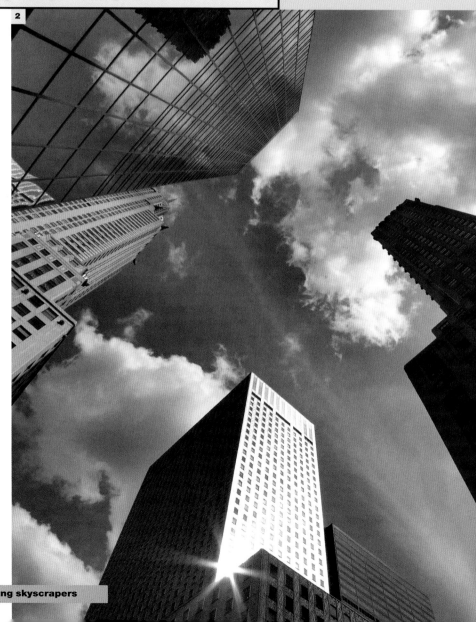

2

> **digital capture**

> **cloning**

> **saturation**

> **channel mixer**

> **levels**

> **curves**

> **dodge and burn**

> **new overlay layer**

> **grey paint**

> **black/white painting**

> **hue/saturation adjustment layer**

her neighbours on East 42nd Street in New York. In this image everything fell together just right and it is a moment that Dave has never seen again.

! Learn Photoshop and learn it well. Ansel Adams' work is still best known for his achievements in the traditional darkroom. His compositions alone are fine, but his work in the darkroom helped to bring his work to the next level.

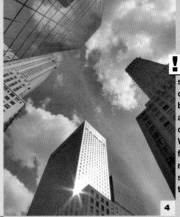

! Shoot in the RAW format if it is available to you. When shooting in JPEG certain criteria such as white balance, colour saturation and sharpness are determined by the camera. When shooting in the RAW format, photographers have much more latitude to make subtle or significant changes to their digital captures.

4

enhance

Dave cloned out the small building he felt detracted from the composition. He then converted the RGB image into monochrome by first over-saturating the individual colour channels in the colour image. This aids the tonal qualities of the final black-and-white print. He then converted to black and white via the channel mixer, with red at 65%, green at 20% and blue at 15% (3).

Levels and curves adjustments were used to bring out more detail in the mid-tones and shadows, while still being careful to avoid overexposure in the highlights (4). The image still needed precise touching up though.

The dodge and burn tools were then used throughout the image to darken the sky and some shadows, while at the same time brightening some of the shadowed areas (5). Although the original image was quite washed out, after correcting for contrast, the difficult

range of dark-to-bright areas in the capture became apparent. A new layer was created and the blend mode set to overlay. It was filled with 50% grey and painted with white or black to dodge or burn the underlying image.

3 channel mixer

Output Channel: Gray

Source Channels

Red: 65 %

Green: 20 %

Blue: 15 %

Constant: 0 %

☑ Monochrome

OK
Cancel
Load...
Save...
☑ Preview

1/ The basic composition was there in this original, but the exposure was quite washed out due to the overpowering glare.

2/ The completed picture has had a hint of sepia toning through a hue/saturation adjustment layer to stop the architecture appearing too cold.

3/ The channel mixer allows a controlled change to monochrome.

4/ Careful use of levels is used to bring out detail.

5/ Dodge and burn gave the finishing touches to the image.

5 dodge and burn

File Edit Image Layer Select Filter View Window Help

enjoy

Dave Martinidez is not a professional photographer, and doubts he ever will be. He likes to consider himself an enthusiast. He does sell his images, both through word of mouth and

through his website, in limited editions. 'Shine', unsurprisingly, is one of his best-selling prints to date.

! Constantly think about seeing things differently. This is a mantra of sorts for Dave as he lives in one of the most photographed cities in the world.

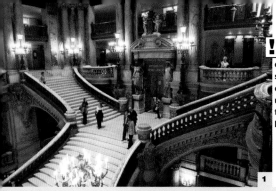

To capture the natural lighting means a long exposure. Try to find something to rest the camera on rather than using higher ISO ratings as these increase the noise levels.

Don't use flash as generally it won't travel far enough to evenly light the entire scene, and will more likely generate ugly shadows.

capturing interiors

Shooting inside buildings brings its own problems, especially when they are sumptuous like the Paris Opera in this picture. The light levels are generally very low, requiring either a tripod – often impossible – or the ability to rest the camera on a flat surface like a balcony. For shooting a classy interior, you want to capture as much of the building and detail as possible, without incurring distorted verticals. The trick to this is to shoot in large spaces where there are no walls on either side of your camera.

shoot

This picture was taken in the famous Paris Opera by Karl Baer of Switzerland. Karl used a Nikon professional digital SLR with a 17–35mm f2.8 wide-angle zoom lens. As there was nothing to rest the camera on and a tripod wasn't allowed, he ramped the digital ISO up to 800 to avoid camera shake.

enhance

As the image was shot on ISO 800 there was copious digital noise in the image. The dust and scratches filter was used on minimum settings to make this a lot less apparent (2).

The side effect of doing this was that the image became quite soft. The unsharp mask filter was used to sharpen the edges without bringing back the original level of noise (3).

There was a colour cast on the original image from the lighting, resulting in an unpleasant yellow-green effect. The colour balance function was used to reduce the yellow and green, and make the image slightly warmer with more red (4).

The curves function was used to increase the shadow detail and raise the brightness of the central walkway

1/ The problems of camera shake were avoided when Karl Baer used a digital ISO rating of 800 for this shot.

2/ Digital noise was removed.

3/ Unsharp mask was used to sharpen the image.

4/ Colour balance was adjusted to add warmth.

5/ Curves was used to increase shadow detail.

6/ With correction to colour cast, contrast and above all else, digital noise, the final image shows off the interior of the Paris Opera.

3 unsharp mask

OK
Reset
☑ Preview

100%

Amount: 50 %

Radius: 3.0 pixels

Threshold: 3 levels

2 dust & scratches

OK
Reset
☑ Preview

300%

Radius: 1 pixels

Threshold: 0 levels

4 colour balance

Color Balance
Color Levels: +16 +10 +16
Cyan ——— Red
Magenta ——— Green
Yellow ——— Blue

Tone Balance
○ Shadows ● Midtones ○ Highlights
☑ Preserve Luminosity

> digital capture
> dust & scratches
> unsharp mask
> colour balance
> curves
> hue/saturation
> CMYK

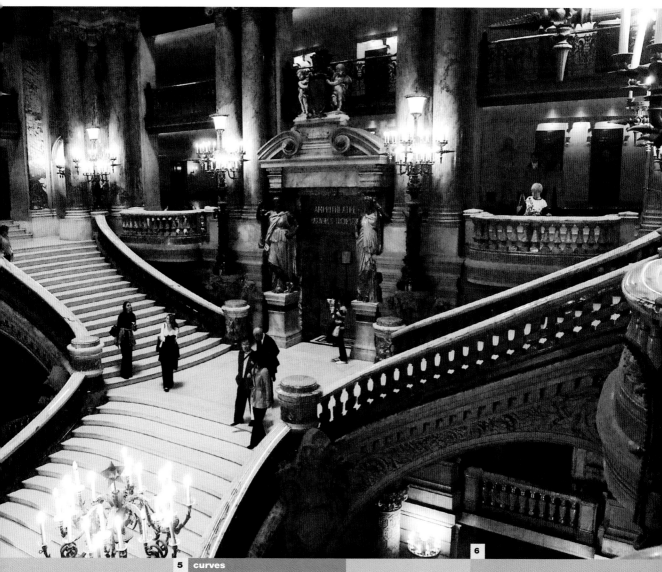

6

area, without increasing the brightness of the lamps. The overall saturation was then increased with hue/saturation.

5 curves

Channel: RGB

OK
Reset
Load...
Save...
Smooth
Auto
Options...

Input: 175
Output: 187

Preview

! Use a wide-angle lens, but shoot away from walls or pillars as they will doubtless show distortion.

enjoy

Karl hasn't made any prints of this picture as yet, its only exposure so far being in this very book. To that end the RGB file was converted to CMYK.

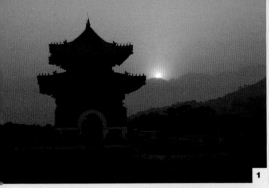

! When using warm-up filters, set the white balance on the camera manually, otherwise it may tune out the effect of the filter.

! Increasing or decreasing the white balance setting beyond what is actually present can be used as a digital alternative to filters.

1

temples and tombs

Temples of worship, tombs, shrines and the like, are great photographic material, but you need to keep out of the way of the crowds of tourists who may also be visiting. To capture a memorable image, either include tourists so as to give the building a human connection, or shoot it as you would a landscape – wait for fantastic lighting and capture it resplendent in the evening glow.

> crop
> selection
> brightness
> invert
> darkening
> red tint
> saturation
> curves
> save for web

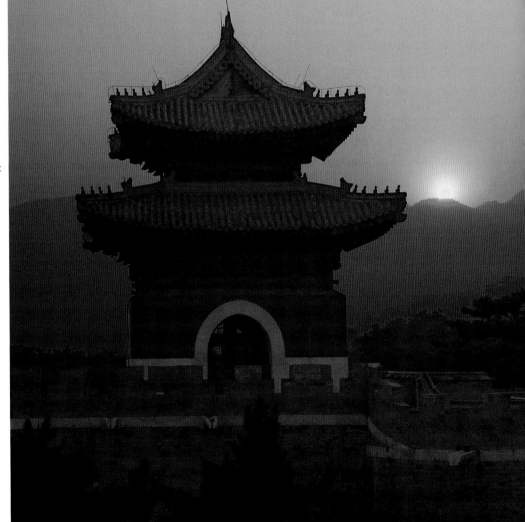

shoot

This photo was taken by Lyle Gellner of Canada, at the Qing tombs (1644–1911) using a consumer digital SLR from Nikon. The Qing tombs are visited less than the Ming tombs, owing to their relative remoteness from Beijing. Located in Zunhua county, this death valley houses five emperors,14 empresses and 136 imperial consorts. In the mountains ringing the valley are buried princes, dukes, imperial nurses and more. The perspective is directly into the last rays of sunlight filtered through the haze on the distant mountain horizon. An 81c warm-up filter was used to enhance the image.

2 crop

3 levels

enhance

The image was cropped to make for a better composition that followed the rule of thirds (2).

The lower portion of the image, including the trees and tomb, was selected and levels used to increase the brightness (3).

The selection was inverted so that the sky and distant mountains could be darkened using levels (4).

A red tint was added and the saturation increased (5). The final adjustment was to use the curves control.

1/ A decent sunset behind an old temple tomb, four hours' drive from Beijing in China.

2/ The image was cropped.

3/ Levels was used to increase contrast.

4/ Inverting the selection in levels, the sky and distant mountains could be darkened.

5/ Finally a red tint was added to the sky.

6/ With the enhanced red colour, this shot now has dramatic impact.

4 levels

5 photo filter

enjoy

The image has been printed out for personal use and Lyle also resized it for website use. The image was then sharpened slightly before saving as a JPEG.

6

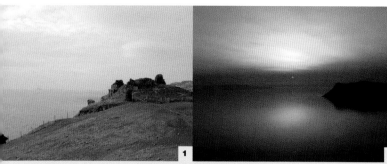

The more moody and atmospheric the picture is, the better. Don't shoot it at midday, although in this particular case, the conditions couldn't have been much duller.

If the ruins have particularly interesting architectural features, get in close for abstract shots.

ruins and fortresses

The crumbling remains of buildings can be powerful reminders of times gone by, especially if they are typical of the history of that country. The only trouble is that a pile of rock in the midday sun is usually not very attractive, so the more ruined the architecture is, the more atmospheric the shot will need to be.

shoot

This is Duntulm castle ruins on the very northern tip of the Isle of Skye in Scotland, UK. It's typical of fortresses and small castles, the ruins of which are scattered across western Scotland, and offers some great, if precarious, views from the ruin itself. The image is a composite, as the sky comes from a photo taken at sunset the day before, from above Uig harbour, which is not far away along the coastline. Both pictures were shot with a Minolta 3Mp digital compact.

3 layers

1/ The ruins as seen during a typically Scottish murky day don't look too inviting.

2/ The harbour at Uig the previous night though afforded a much more spectacular sky with a dramatic sunset.

3/ The blend mode was set to overlay and the horizons of the two images were aligned.

4/ Next the gaussian blur filter was applied.

5/ A gradient fill was used on a new layer to add shadows to the corners of the image.

6/ The completed image features a sunset from the night before and gives the ruins a real sense of drama and atmosphere.

> digital capture
> copy & paste
> overlay blend mode
> layer mask
> gaussian blur
> curves
> hue/saturation
> cropping
> gradient fill
> save as TIFF
> save for web

enhance

Pretty much all of the Uig picture was selected, copied and pasted as a new layer on to the Duntulm castle picture. The blend mode was set to overlay and the horizons of the two pictures were aligned (3).

A layer mask was added and the harbour cliffs from Uig and the islands on the horizon were masked out. Variable amounts of the sunset light were then allowed through on to the grass by using a reduced opacity paintbrush on the mask. The layers were merged and the sky was selected. A heavy gaussian blur was applied to it (4). The contrast and saturation were then increased. The image was cropped to get rid of

4 gaussian blur

OK

Reset

☑ Preview

100%

Radius: 44.5 pixels

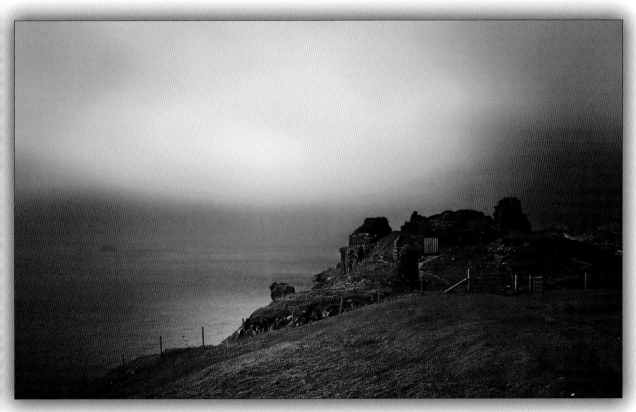

Duncan Evans LRPS

Duntulm Castle, Isle of Skye

some of the foreground and empty space to the left, then a gradient fill was used on a new layer to add shadows to the corners of the image, concentrating attention to the middle.

**! ** Rain, snow and fog are all excellent props in shooting ruins. Keep water off the lens and use a tripod if necessary as the narrow aperture required for greatest depth of field will reduce the shutter speed.

enjoy

The image was reduced to 500 pixels on the long side for displaying on the web folio site of the Digital Image Group, which is part of the Royal Photographic Society. The unsharp mask filter was used to restore some of the sharpness lost. At the time of writing, the image has only been seen in print, here in this book.

5 ** **layers

! Aim to show the deterrent that the structure was built to create, don't just zoom in on some fancy stonework.

1

shoot

Jorge Coimbra of Amadora, Portugal shot this picture of Torre de Belem, which defends Lisbon on the side where the Tejo river flows. The usual shot of this fortress is one showing the many beautiful buildings behind it, but Jorge went for the more unusual

ruins and fortresses cont.

A long legacy of warfare has left castles, defensive emplacements, forts and fortresses scattered across the landscape of many countries around the world. Whether to protect the population from invaders, or to keep the population inside, the medieval period in particular was a golden age for building. View these monuments now as part of that country's past heritage.

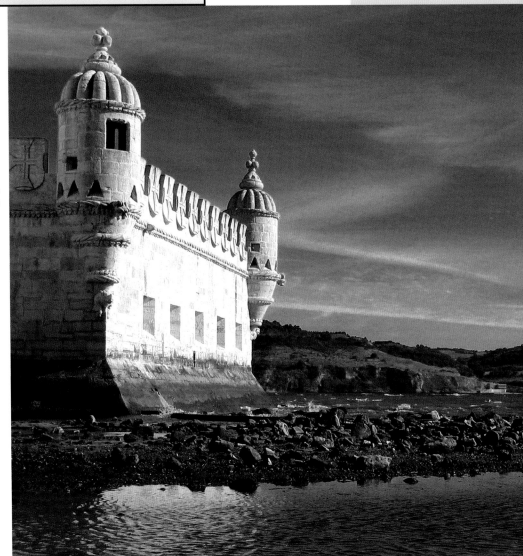

> digital capture

> canvas rotate

> crop

> brightness/contrast

> channel mixer

> curves

approach of showing the tower facing out to the river and potential invaders. It was shot with a Canon compact digital camera with a 4x optical zoom.

enhance

First, the picture was slightly rotated in an anti-clockwise fashion to straighten it up. After that it was cropped to remove the empty space at the bottom of the image (2).

The contrast and brightness were then adjusted to give the picture more impact (3).

The picture was then converted to black and white by using the channel mixer with settings of red: 80%, green:

2 crop

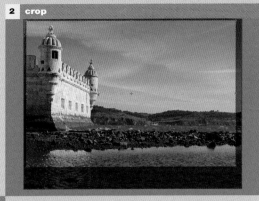

20% and blue: 0%. The blue of the sky became a dark grey, retaining the white of the clouds (4). Finally, more contrast was introduced by using the curves function, which resulted in a much more dramatic image (5).

1/ The colour image of the Torre de Belem shows it facing out towards the river.

2/ The image was cropped for better composition.

3/ Contrast and brightness were adjusted to make the image stronger.

4/ The channel mixer was applied to make the image black and white.

5/ Curves was used to introduce more contrast.

6/ Rendered in punchy black and white, this serves as a powerful image of more warlike times in Portugal.

3 brightness/contrast

4 channel mixer

Output Channel: Gray

Source Channels
Red: +80 %
Green: +20 %
Blue: 0 %

Constant: 0 %

☑ Monochrome

OK
Reset
Load...
Save...
☑ Preview

5 curves

Channel: Gray

Input: 70 %
Output: 81 %

OK
Cancel
Load...
Save...
Smooth
Auto
Options...
☑ Preview

enjoy

Jorge makes prints for his own enjoyment and some images have been printed in reviews and books. For web use he usually adjusts the image size to between 700 and 800 pixels along the biggest side if in

landscape format, slightly less in the portrait format. A file size of about 150k is usually acceptable in terms of image quality.

! Use a high manual white balance setting with the afternoon sun to bring out the colour of old stonework.

6

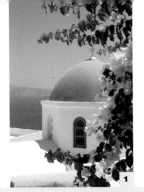

! When shooting white walls in sunny conditions there can be the tendency to underexpose the photo because of the reflectivity. Set +0.5 exposure compensation and take a second shot.

3 curves

Channel: RGB

OK
Cancel
Load...
Save...
Smooth
Auto
Options...

Input: 181
Output: 200

☑ Preview

capturing local colour

In certain parts of the world, particularly the hot ones, there is the style to combine traditional white-washed walls, which repel heat, with brightly coloured roofs, window frames, and doors etc. This is particularly prevalent in the Mediterranean. As such, the pure white and startling colour provide a clean, fresh colour scheme, especially when set against perfect weather conditions.

shoot

Mellik Tamás of Budapest, Hungary shot this picture on the island of Santorini in Greece, in the Mediterranean. He had always loved this place with the blue rooftops and shining sun, and he just wanted to show it with even more colour, hence the inclusion of the blooms in the foreground. Mellik was only on the island for a short time before he had to get back on the boat to Crete. He shot the picture with a Fuji consumer digital SLR and a Tokina 28–70mm f2.8 AT-X lens.

2 clone tool

enhance

First the hand and patches of grass along the bottom of the wall were cloned out using the clone stamp tool. The dot in the distance next to the dome was also removed (2).

Then the brightness and contrast were increased with the curves function so that the walls looked brighter (3).

Lastly, the saturation was increased so that the image was as blue as in real life (4).

4 hue saturation

Edit: Master

Hue: 0
Saturation: +20
Lightness: 0

OK
Reset
Load...
Save...

☐ Colorize
☑ Preview

enjoy

Mellik only makes prints from a few of his pictures. He is the joint owner of a small advertising agency and sometimes they sell some of his pictures to their customers, using them in flyers, leaflets, presentations, etc. One of his first customers was National Geographic Books – it bought a picture to use on a Hungarian book cover. Mellik uses Photoshop to prepare his pictures for web use. First he adjusts the size then the sharpness.

! Don't believe your eyes when you look at the little LCD monitor. What you see is not always what you get – always check the aperture and shutter values.

> digital capture
> cloning
> curves
> hue/saturation
> resize
> sharpen

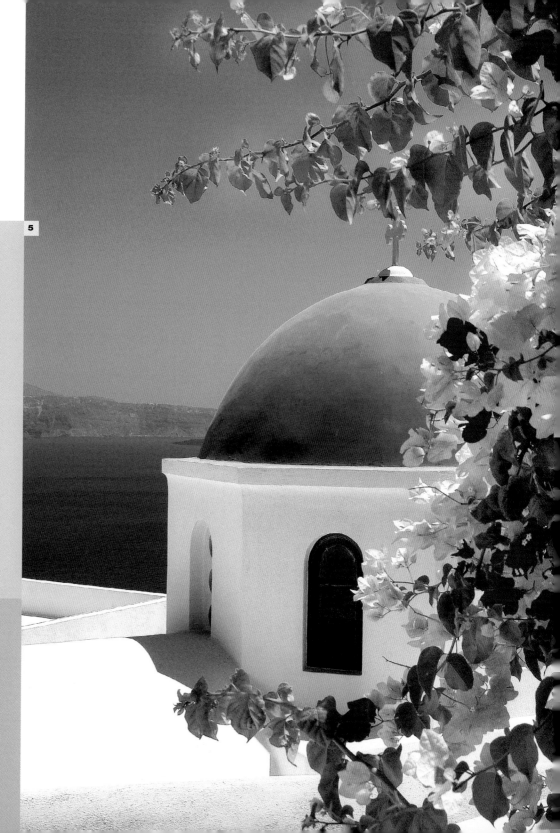

! The Automatic White Balance can rob a scene of the golden colour of sunshine. Try some manual settings with high values.

5

1/ In this picture of buildings on the island of Santorini, the colours are washed out.

2/ The clone stamp tool was used to remove blemishes.

3/ To make the walls look brighter, brightness and contrast were increased.

4/ Colour saturation was increased at the end to make the blues vibrant.

5/ Now the colours are as bright and sunny as the day the photograph was taken.

9 special digital processes

While this entire book is of course dedicated to digital enhancement of travel images, there are extra stages that can be taken to produce the evocative result that you are after. Whether this is adding skies, people or using the unique digital ability to shoot in colour and convert to black and white, it is up to you how far you take these processes.

'The Little Church' by Aldo Costantini features a replacement sky as the one present when shooting was dull and uninspiring. Aldo shot it with a Nikon consumer digital SLR with a Nikkor AF-S 18–70mm lens.

Aldo says: 'I did this shot of a little church one summer morning, in Pusteria Valley. This is a very beautiful place in the Italian Alps. The light was very good, but the sky behind the church was too plain and I thought that I would change it later. I have many shots with different and dramatic skies, which I shoot in different places, with the aim of using them later.'

photographers

Aldo Costantini
Bjørn Rannestad
Nour Eddine El Ghoumari

1 The tiny state of San Marino captured by Aldo Costantini. Unfortunately the dreary sky lets the picture down.

2 Aldo shoots lots of cloud formations for use in compositions just like this.

3 The magic wand was used to select the sky.

4 After the sky was deleted, the edges were softened with the blur tool.

5 The photo filter was applied to add warmth.

6 The new sky was pasted in as a new layer.

7 Finally, the warming filter was used on the sky to match the landscape colour.

8 With a dramatic and moody sky replacing the original dull one, the image really comes alive.

replacing skies

It's the curse of travelling that when you visit a stunning location the weather and sky conditions will be dismal, yet when you are sat in an office looking out of the window it will be a post-apocalyptic sunset. Enter the world of digital chicanery, where you can replace the sky with one more to your own choosing.

shoot

San Marino is a tiny independent state inside Italy. Aldo Costantini of Perugia, Italy shot this image with a Nikon consumer digital SLR and a Nikkor AF-S 18–70mm short telephoto lens. The town is arranged around three towering rock formations and Aldo shot the most important one, from one of the other formations. The light was very good at the time, but the sky was hugely disappointing.

5 photo filter

Use

- ● Filter: Warming Filter (81)
- ○ Color:

Density: 80 %

☑ Preserve Luminosity

3 magic wand
4 layers

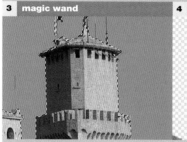

enhance

A duplicate layer was created and the magic wand used to select the sky with a Tolerance of 32. This was feathered by two pixels (3). The sky was then deleted and the edges softened with the blur tool (4).

The landscape was warmed up by using the photo filter with the warming filter option set at a density of 80 (5).

The brightness and contrast of the landscape were reduced by 10%. Then the new sky image was pasted in as a new layer. The brightness of this was reduced by 20% and it was

dragged under the landscape layer in the layers palette (6).

Finally, the warming filter was used on the sky to make it match the colour of the landscape (7). Then the layers were merged.

> digital capture

> duplicate layer

> magic wand

> blur

> warming filter

> brightness/contrast

> new layer

> warming filter

> merge and save

> convert to CMYK

6 paste new layer

7 photo filter

Use

- ● Filter: Warming Filter (81)
- ○ Color:

OK
Cancel
☑ Preview

Density: 80 %

☑ Preserve Luminosity

! Water poses additional problems as this not only reflects what is in the sky, but the light also affects how blue the water will look.

! Ensure that the perspective the sky was shot from matches that of the photo where you are replacing the sky, otherwise it will look odd.

! When changing the sky for one that is more dramatic, particularly at sunset, you must also consider the effect that the light would have on the landscape itself and tint accordingly.

enjoy

Aldo currently only makes prints for his own enjoyment. To use in this book the image was converted to CMYK and saved as a TIFF.

8

1

! Examine the three colour channels to see what they look like in black and white, and use this as the basis for conversion using the channel mixer.

! The channel mixer is the best method of conversion to black and white, offering both the most flexibility and also because it leaves the image as an RGB file, not greyscale.

converting to mono

Unlike film, the digital image is originally colour, from which a black-and-white version can be extracted. The trick is in how the image is extracted and how it is subsequently used. Creating black-and-white images has as much relevance to travel photography as colour, concentrating on form, texture and light.

shoot

Bjørn Rannestad of Aalborg, Denmark saw this scene at the Louvre in Paris, France and decided it would make an excellent black-and-white study, as it was all about shapes and light, rather than colour. At first Bjørn didn't want any tourists in the photo, but soon he realised that it was the tourists that made this particular photo. He shot it with a Sony compact digital camera.

enhance

The image was resized and rotated around to a portrait orientation. The bright parts to the left and right of the gate were cloned out (2).

In the channels tab of the layers palette, the green channel was dragged over to a blank image file to create a greyscale image based on that channel (3). The image was then cropped to move the gate more to the left, and the

2 clone tool

3 copy channel

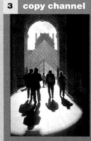

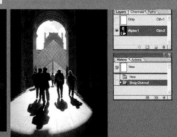

contrast was tweaked and the image sharpened (4).

4 unsharp mask

OK
Reset
☑ Preview

⊟ 100% ⊞

Amount: 50 %

Radius: 3.0 pixels

Threshold: 3 levels

enjoy

Bjørn makes prints for his own enjoyment. When he prepares an image for web use for digital photo contests, he resizes down and uses the unsharp mask to make it sharper.

> digital capture
> resize
> rotate
> cloning
> green channel
> crop
> contrast
> sharpening

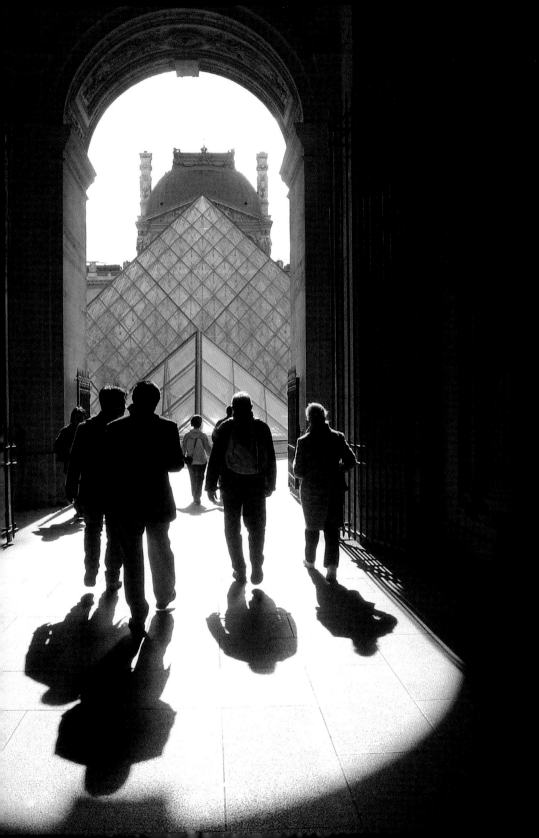

5

1/ Although originally a colour photo, what colour there is actually detracts from this photo, instead of adding to it.

2/ The clone tool was used to remove unwanted elements.

3/ The green channel was dragged over to a blank image file to create a greyscale image.

4/ The image was sharpened using the unsharp mask.

5/ Once converted to black and white, the image becomes much more dramatic and stylised.

! **A black-and-white RGB file can use the full range of Photoshop filters, a greyscale mode picture cannot.**

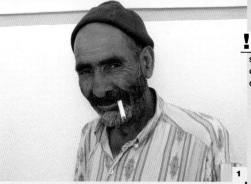

! When combining elements it is worth taking your time over the selection process, as a properly cut-out image will make all the difference.

2 curves

Channel: RGB

OK
Reset
Load...
Save...
Smooth
Auto
Options...

Input: 140
Output: 117

☑ Preview

adding people

The power of digital means that it is possible to add people or elements to scenes that weren't originally there. The ethics of doing this are debatable, and the acceptability is largely dependent upon what use the image will have. If it is being presented as a factual record, then it isn't acceptable, but if it is a general illustrative or artwork piece then it is, as long as it is not claimed to be one single image.

shoot

Nour Eddine El Ghoumari took the original image of the Egyptian temple with the man in the distance in 1999 using a Minolta 35mm film SLR. However, he felt the image was lacking something until he took the image of this man smoking six years later with an Olympus consumer digital SLR and decided to combine the two images into one.

The image of the smoker was taken in Morocco. Nour was going around a market place in a small village called Jbarna in the region of Taza. He came across this man, a beggar, wearing dirty clothes and torn plastic sandals. Nour initially took a picture of him without asking him, but then asked him to stand still while he took his portrait. Nour told him he was using a magical camera and that the pictures could be seen within seconds. The beggar looked excited, so Nour asked him to put the cigarette in his mouth and look at the camera. At the end, he showed the beggar his pictures, gave him some money and left.

3 dodge & burn

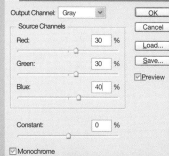

! Ensure that light and shadows on the two elements match, otherwise the composite image will look totally false.

enhance

The original image was scanned and loaded into Photoshop. The exposure was corrected using levels, curves (2) and brightness/contrast.

The dodge and burn tools were used to bring out parts of the background and to make it look more mysterious (3). A black sky was added using the gradient tool and a cloud effect was pasted on top of that.

The smoker image was then loaded and converted to black and white

4 channel mixer

Output Channel: Gray

Source Channels
Red: 30 %
Green: 30 %
Blue: 40 %

Constant: 0 %

☑ Monochrome

OK
Cancel
Load...
Save...
☑ Preview

5 pen tool

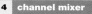

> film capture
> scan
> levels and curves
> dodge and burn
> gradient
> digital capture
> channel mixer
> pen tool
> copy and paste
> levels and curves
> dodge and burn
> merge layers
> sharpening
> sepia tone

1/ This picture was shot six years after the original temple photo, using a digital camera.

2/ Curves was used to correct the exposure of the original image.

3/ The background was enhanced using the dodge and burn tools.

4/ The image of the man smoking was converted to mono using the channel mixer.

5/ The pen tool was selected.

6/ Dodge and burn tools were used to give the figure the same tonal qualities as the rest of the image.

7/ Unsharp mask was applied to the image to sharpen it.

8/ The composite image uses film and digital technology to create a stunning, atmospheric result.

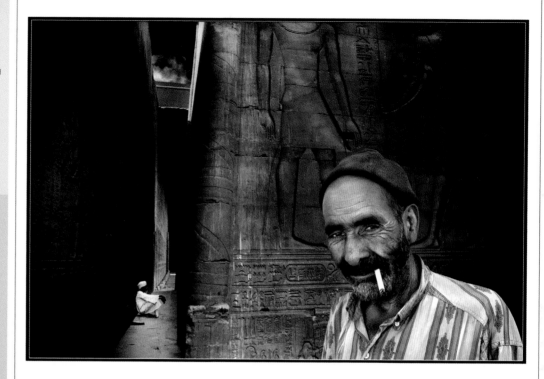

8

6 dodge & burn

using the channel mixer (4). The pen tool was then selected and used to mark around the figure (5). Once completed, the path was right-clicked on and the option to create a selection chosen. The selection was chosen and the man copied and pasted as a new layer over the background image.

Levels, curves, dodge and burn (6) were then used to enhance the figure and make him have the same tonal qualities as the rest of the image.

After other minor tweaks around the image, and whitening of the man's eyes, the layers were merged, the image was sharpened (7) and a slight sepia tone applied.

The contents of the disparate elements need to be sympathetic in look and style, otherwise the resulting image will not be convincing.

7 unsharp mask

OK

Reset

☑ Preview

⊟ ⊞

Amount: 50 %

Radius: 3.0 pixels

Threshold: 3 levels

enjoy

Nour is a serious amateur and takes and makes images for his own enjoyment, as well as exhibitions. He also works with two famous poets from Morocco. They often publish poems and images for a national newspaper in the culture pages. This image was displayed in the Travel section on Photo.net, where it was awarded image of the week. However, when it was revealed that it was a composite, there was considerable debate, with some people being for the image and others being against it.

appendix

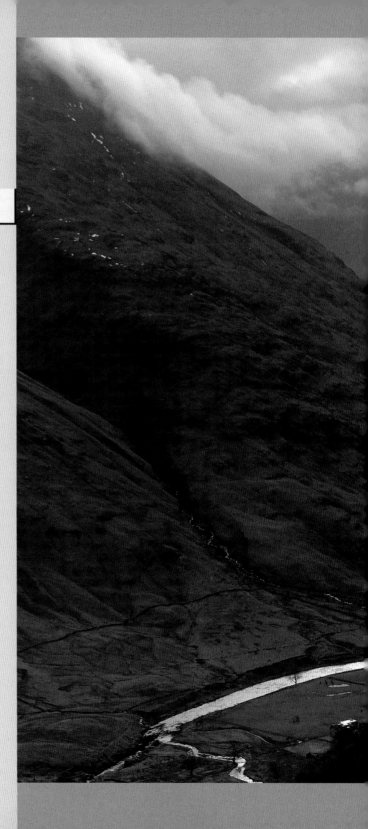

This picture was taken during a week-long stay in Glencoe, Scotland, UK by Les McLean. On this day Les was climbing Stob Dubh mountain in Glencoe with the River Etive and Loch Etive in the distance. The weather was misty and damp. About halfway up the mountain, the light improved and the mist partly cleared to enable a photograph.

Les says: 'What was important for me was to ensure a necessary depth to the composition, therefore the river is a vital component to the scene. Without it, the image is flat.'

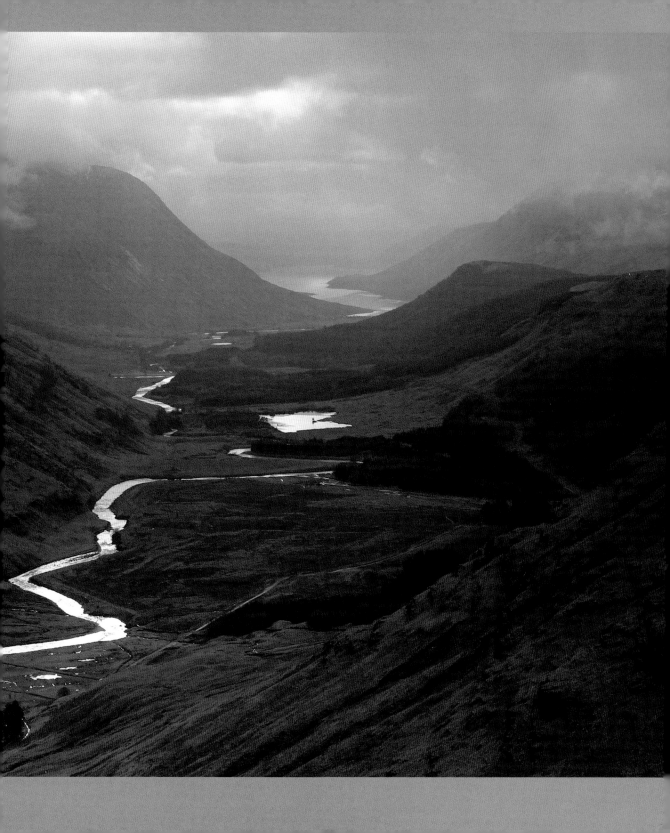

Lindis Pass by Mike Hollman

glossary

Adobe RGB 1998: Colour profile based on the RGB system with a wide colour gamut suitable for photographic images. See sRGB.

Aperture: The opening to a camera's lens that allows light into the camera to strike the CCD. See f-stop.

Aperture priority: Camera shooting mode. Allows the user to set the camera's aperture (f-stop) while the camera calculates the optimum exposure time.

APS: Acronym of Advanced Photo System.

Artefact: Minor damage or fault on a photograph, usually caused by JPEG file compression.

Automatic white balance: System within a digital camera that removes colour casts caused by the hues of different types of light.

Bit: Binary digit. Smallest unit of information used by computers.

Bitmap: Digital image made of a grid of colour or greyscale pixels.

Byte: A string of eight bits. 1024 bytes make a kilobyte (KB), and 1024KB make a megabyte (MB).

CCD (charge coupled device): Electronic device that captures light waves and converts them into electrical signals.

CD-R: A compact disc that data can be written to, but not erased.

CD-RW: CD-RWs can be erased and used a number of times.

Chromatic aberration: Colours bordering backlit objects. Caused by the poor-quality lens systems used in many compact cameras. Can also affect high-quality optical systems, but only to a limited degree.

CMOS (Complementary Metal Oxide Semiconductor): A light-sensitive chip used in some digital cameras and scanners instead of CCDs. CMOS chips are cheaper to develop and manufacture than CCD chips, but they tend to produce softer images.

CMYK: Abbreviation for cyan, magenta, yellow and black – the secondary colours from which colours can be derived. CMYK is used to reproduce colours on the printed page and has a narrower gamut than RGB. See RGB.

CompactFlash: A type of memory card with the interface built in.

Compression: Process that reduces a file's size. Lossy compression systems reduce the quality of the file. Lossless compression does not damage an image. See JPEG.

Digital image: A picture made up of pixels and recorded as data.

Digital zoom: Process that simulates the effect of a zoom by cropping photos and enlarging the remaining image. Reduces image size. See Interpolation and Zoom lens.

Download: Process of transferring data from one source to another, typically a camera to a computer.

dpi (dots per inch): A measurement of print density that defines the image size when printed, not its resolution.

DVD: Digital Versatile Disc. High capacity storage medium like CD, but offering six times the space.

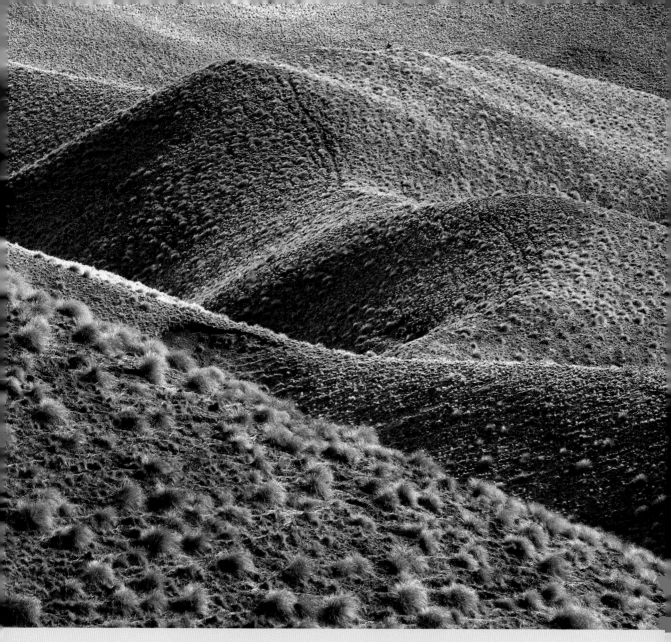

DVD-R: Most common type of recordable DVD disc. While multisession compatible, data cannot be erased.

DVD-RW and DVD+RW: Erasable and re-recordable versions of DVD.

Dynamic range: The range of the lightest to the darkest areas in a scene that a CCD can distinguish.

Electronic viewfinder: A small LCD display that replaces optical viewfinders in some digital cameras.

Exposure value (EV): Measurement of a photograph's brightness.

Exposure compensation: Adjustment applied to a photograph to correct exposure, without adjusting the aperture or shutter speed.

f-stop: A camera's aperture setting. A high f-stop number means the camera is using a narrow aperture.

File size: A file's size is determined by the amount of data it contains.

Image-editing software: A program used to manipulate digital images. Also known as image-processing, image-manipulation, photo-editing or imaging software.

Image resolution: The number of pixels stored in a digital image.

GIF: Graphic Interchange File. Common internet graphic format, used for banners and icons where few colours are required.

Ink jet printer: Printer that sprays fine dots of ink on to paper to produce prints.

Interpolation: A process to increase an image's resolution by adding new pixels. This can reduce image quality.

JPEG (or JPG): File format that reduces a digital image's file size at the expense of image quality.

k/s: Kilobyte per second. A measurement of data transfer rates.

Kilobyte (k or KB): Unit of computer memory. Equal to 1024 bytes.

LAB colour: Colour mode consisting of lightness channel and two colour channels, A covering green to red, and B covering blue to yellow colours.

Laser printer: Printers that print documents by fusing toner or carbon powder on to paper surface.

LCD (liquid crystal display): A small light display. Lit by running a current through an electrically reactive substance held between two electrodes.

LCD monitor: A small, colour display built into most digital cameras. Allows the user to preview/review digital photos as they are taken.

Lithium-ion (or Li-ion): Powerful rechargeable batteries. Not affected by the memory effect. See Ni-Cd.

MAh (milliamp hours): A unit of measure to describe a battery's power capacity.

Mb/s: Megabyte per second. A measurement of data transfer rates.

Megabyte (Mb or MB): Unit of computer memory. Equal to 1024 kilobytes.

Megapixel (Mp): A million pixels. A standard term of reference for digital cameras. Multiply the maximum horizontal and vertical resolutions of the camera output and express in terms of millions of pixels. Hence a camera producing a 2400 x 1600 picture would be a 3.8Mp camera.

Memory effect: The decrease of a rechargeable battery's power capacity over time.

Memory Stick: Sony's proprietary solid state storage media.

Microsoft Windows 2000: A Windows NT-based system used for businesses.

Microsoft Windows 98/Me: Home user operating system used on PCs. Now superseded by Windows XP.

Microsoft Windows NT: The Microsoft operating system designed for businesses using more secure file handling and access. Now outdated.

Microsoft Windows XP Home: The current direction of Windows. This version is based on the NT kernel, but designed for home users.

Microsoft Windows XP Professional: Version of XP for home users, professionals or small businesses.

Microdrive: A miniature hard drive offering large storage capacities that can be used in digital cameras with a CompactFlash Type II slot.

Multimedia card: A type of storage media used in digital devices.

Ni-Cd or Nicad (nickel cadmium): Basic type of rechargeable battery. Can last up to 1,000 charges, but can suffer from the memory effect. See Memory effect.

NiMH (nickel metal hydride): Rechargeable battery. Contains twice the power of similar Nicad batteries. Also much less affected by the memory effect. See Memory effect.

Optical viewfinder: Viewfinder that delivers an image of the scene either directly, or via mirrors, to the user, without recourse to electronics or an LCD.

Outputting: A process of printing an image or configuring an image for display on the internet.

PC card: Expansion card interface, commonly used on laptop computers. A variety of PC cards offer everything from network interfaces, modems to holders for digital camera memory cards. Some memory card readers use PC card slots (or PCMCIA cards).

PC sync: A socket on a camera that allows the camera to control studio flash systems.

Pen tablet: Input device that replaces a mouse. Moving a pen over a specially designed tablet controls the cursor.

Photoshop: Industry-standard image manipulation program produced by Adobe.

Pixel: A tiny square of digital data. The basis of all digital images.

Pixellation: The effect when individual pixels can be seen.

Plug-in: Software that integrates with a main photo-editing package to offer further functionality.

PNG: Portable Network Graphics. A file format commonly used for images used on the internet. Can be defined in anything from 8-bit to 48-bit colour.

Printer resolution: The density of the ink dots that a printer lays on paper to produce images. Usually expressed as dpi (dots per inch), but note that this is not the same thing as the dpi of an image.

RAW: This file format will record exactly what a camera's CCD/CMOS chip sees. The data will not be altered by the camera's firmware (images are not sharpened, colour saturation is not increased, and noise levels will not be reduced).

RGB: Additive system of colour filtration. Uses the combinations of red, green and blue to recreate colours. Standard system in digital images. See CMYK.

Secure Data (SD): A type of solid-state storage medium used in some digital cameras.

Shutter priority: Camera shooting mode. The user sets the camera's shutter speed, while the camera calculates the aperture setting.

SLR: Single Lens Reflex camera. Has the advantage that the image it shows through the optical viewfinder is the one that the camera sees through the lens. Digital SLRs are much faster, more responsive and more powerful than compact digital cameras.

SmartMedia: Type of storage card used to store digital images. Very popular digital camera format, now replaced by x-D Picture Card format.

sRGB: Common, but limited colour gamut, profile of the RGB system. Most commonly used in digital cameras. See Adobe RGB.

Thumbnail: A small version of an image used for identifying, displaying and cataloguing images.

TIFF: Image file format. Used to store high-quality images. Can use a lossless compression system to reduce file size, without causing a reduction in the quality of the image. Available on some digital cameras as an alternative to saving images using the JPEG format.

TTL (through-the-lens) metering: A sensor built into a camera's body that uses light coming through the lens to set the exposure.

USB 1.1 (Universal Serial Bus v1.1): External computer to peripheral connection that supports data transfer rates of 1.5Mb/s. One USB 1.1 port can be connected to 127 peripherals.

USB 2.0 (Hi-speed USB): A variant of USB 1.1. Supports data connection rates of up to 60Mb/s. USB 2.0 devices can be used with USB 1.1 sockets (at a much reduced speed), and USB 1.1 devices can be used in USB 2.0 sockets.

VideoCD: The forerunner to the DVD video format. Lower resolution than DVD video, but is used with standard CDs. Can be played on PCs.

WYSIWYG: Acronym of 'what you see is what you get'. A term for a computer interface that outputs exactly what is seen on screen.

xD-Picture Card (xD Card): Memory card format that has been developed by Toshiba, Fujifilm and Olympus. Designed as a replacement for SmartMedia.

X-sync: The fastest shutter speed at which a camera can synchronise with an electronic flash.

Zoom lens (Optical zoom): A variable focal length lens found on most cameras. Used to enlarge images. See Digital zoom.

contacts

Hassan Ahmed

Hassan was born in Cairo, Egypt, but has lived in Italy since 1995. Visual arts in general were amongst his hobbies until he developed a particular interest in digital photography in 2002. Macro, landscape, cityscapes, abstract, and night photography are mainly the categories that he is studying, exploring, and experimenting with at the moment.

Pages 20–21

www.hassan.tv

hassan@hassan.tv

John D. Andersen

John lives in South Florida, USA with his family. The son of a photographer, he spent many days watching his father develop images in the family darkroom. While he always enjoyed photography, he didn't pursue it seriously until the development of digital SLRs. John currently specialises in fine art nature photography, and exhibits at fine art shows through his business, Images by JDA.

Pages 56–57

www.imagesbyjda.com

south_fl@snappydsl.net

Anthony Arendt

Landscape photography has and always will be one of Anthony's great passions. He sells fine art prints through his website. His work has appeared in National Geographic Traveller, Peterson's Photographic, and the Sierra Club along with many other national and international publications.

Pages 92–93

www.anthonyarendtphoto
graphy.com

tonyarendt@comcast.net

Karl Baer

As a student Karl discovered an interest in photography, but it wasn't until July 1999 that he bought his first digital camera. In 2001, he upgraded to professional equipment and now – along with a part-time job in the Swiss Social Security – he is working as a freelance photographer.

Pages 44–45, 108–109, 116–117

www.karibaer.ch

karibaer@bluewin.ch

Nancy Grace Chen

Nancy Grace Chen first became fascinated with photography in 2002. Soon thereafter, she dedicated herself to learning all she could through books, online competitions and critique websites, taking her primary interest, scenes involving people. Currently, Nancy is a 24-year-old student who spends far too much time shooting with her Canon EOS 10D.

Pages 96–97

www.nacespace.com/
photos

mail@nacespace.com

Jorge Coimbra

Jorge Coimbra is 44 years old and works professionally as an engineer. He is an amateur photographer. He used to be interested in photography as a teenager, but his enthusiasm was fired up again about five years ago when he bought his first digital compact camera. He prefers natural and humanised landscapes as subject matter.

Pages 122–123

www.jorgecoimbra.home.
sapo.pt

jorcoimbra@yahoo.com

Aldo Costantini

Aldo Costantini uses a Nikon digital SLR with a range of Nikon lenses for his landscape work. For Aldo, the image-making process is all about collecting the elements when you can, then when inspiration strikes, putting all the right pieces together to create stunning imagery.

Pages 126–127

http://www.photonet/
photodb/member-
photos?user_id=5989418&
include=all

aldo.costantini@tin.it

Gavin Davies

Gavin's interest in photography started in 2001 when he bought his first digital camera. Since upgrading in 2003, his passion for photography has flourished. His photographic subjects have included a few weddings, portrait work, landscapes, macros, infrared, and wildlife.

Pages 80–81

http://freespace.virgin.net/
gnd.photography/index.
html

gav_davies@hotmail.com

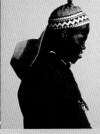

Krys Bailey

Krys has been taking pictures since she was just old enough to hold a camera. Her passion has always been mountain landscapes. After much experimentation, she acquired her first digital SLR in 2003. A visit to Chile to capture the stunning landscape inspired her to turn her photography 'hobby' into a new career.

Pages 38–39, 46–47

www.marmotta-photoart.co.uk

krys@marmotta-photoart.co.uk

Markos Berndt

Markos discovered photography four years ago, mainly shooting flowers and macro types of photos. When he bought a Minolta Dimage he was able to shoot landscapes. He has stuck with landscapes for the past two years. Winter and spring are his favourite times of year to take photographs.

Pages 10–11, 15, 35–37

www.artwanted.com/markosb

markosphoto@tds.net

Nick Biemans

At the age of 11, Nick received his first camera as a present; a two-eyed Lubitel. He likes to shoot animals and many of his images have been published. Photography has become a part of Nick's life. Everyday he is busier with it alongside his work with mentally handicapped people. He finds it is a nice way to relax, in particular when combined with a walk outside.

Pages 5, 82–83

www.nickbiemans.nl

info@nicksphotosite.nl

Gustaf L. Bjerne

Gustaf works as a freelance photographer with a special interest in travel and portrait photography. At least twice a year he packs his bags and leaves Sweden for equatorial destinations. His favourite countries are to be found south of the Sahara. This is where he really feels alive and his creativity is awakened.

Pages 54–55

www.bjerne.se

gustaf@bjerne.se

Michael Boyer

After starting out with a cheap digital camera, Michael Boyer upgraded to a 3Mp compact. As fate would have it, it was about the same time he moved to Europe for a three-year business assignment giving him ample opportunity for lots of travel snapshots. Mike currently lives in Miami. His favourite topic is travel photography with a focus on still life.

Pages 28–29, 106–107, 112–113

www.boyerpics.com/

mike@boyerpics.com

Terry Cervi

Terry lives in Kenmore, NY, a suburb of Buffalo, a beautiful area with Lakes Erie and Ontario to the north and south, and Niagara Falls just a 20-minute drive away. Terry's love for digital photography began to grow five years ago. What makes photography so much fun for Terri, is never knowing what's around the corner and the challenge of being able to capture that new find in a way that's pleasing to the eye.

Pages 86–87

www.terrycervi.com

bltg@adelphia.net

Nour Eddine El Ghoumari

Nour always likes to connect with people. He does not want his pictures to be soulless because he makes pictures for himself first and he is the one who enjoys them most. He developed an interest in compositing images after seeing a BBC program. He feels that if we cannot come together in reality then it can be done digitally.

Pages 132–133

www.photonour.com

nour@photonour.com

Rod Edwards

Rod Edwards is a professional photographer working in the publishing, advertising, design and corporate areas of the photographic industry and has worked for many major clients. He markets his images from home and also through international photographic agencies and is also a member of the Association of Photographers in London.

Pages 98–99

www.rodedwards.com and www.rodedwards.co.uk

studio@rodedwards.com

Alec Ee

Alec is glad to say that some of his images are represented in stock photography companies and sold at www.photo4me.com. Sharing his images on Photo.net has not only motivated him to improve his photographic skills, but also synergised his marketing efforts with his international distributors.

Page 7

www.elanist.com/alec

alecee@photo.net

Duncan Evans LRPS

Duncan is the author of this and another seven photographic books. He was the Editor of the magazine, Digital Photography Buyer & User (previously Digital Photo User) for over four years and is an expert in digital photography hardware and software editing techniques. He is a member of the Royal Photographic Society.

Pages 12–14, 16, 66–67, 120–121

www.duncanevans.co.uk

dg@duncanevans.co.uk

Karl Facredyn

Karl works as a commercial photographer in New York, USA and uses a Canon digital SLR for his portraits. He always shoots in RAW format so that the quality is better and the image can be optimised. His advice to would-be photographers when using digital, is to avoid high contrast scenes as the dynamic range in digital is still too small to cope with it.

Pages 64–65

karl@orangelogic.com

Lyle A. Gellner

Twelve years ago Lyle combined two passions, travel and photography, and spent most of his leisure time on this combination. This obsession really manifested itself with the advent of digital scanning, digital photography and web posting. Lyle is currently focused on the canyons, landscapes and seascapes of the American South West and the Pacific North West.

Pages 72–73, 118–119

http://lylegellner.photoblink.com

Lag3@shaw.ca

Rob Gray

Born in 1954, Rob has travelled all over the world. During these travels he worked in photography-related jobs and wrote and photographed articles for travel magazines. In 2000 Rob sold most of his possessions, quit his job, and started life on the road in Australia's largest and weirdest off-road motor home, exploring and photographing Australia.

Pages 30–31
www.robgray.com
rg@robgray.com

Thomas Guffey

Thomas lives on the West coast of the USA. He is a published photographer, creating cards, calendars and large-format landscapes. He is also a member of a great number of photographic institutions. Thomas also writes a monthly travel/best places column for various magazines and websites.

Pages 74–75
www.agofs.com/guffeyt1.htm and
www.photoportfolios.net
shootingseattle@aol.com

Mike Hollman

Mike started in photography about 15 years ago, but switched to digital two years ago and now uses Nikon digital cameras for most of his work. He has worked for various photo agencies over the past ten years and has had photos published in books, calendars and as postcards. Presently he prefers shooting travel and landscape images, and has travelled extensively throughout New Zealand and Asia.

Pages 62–63,136
www.mikehollman.com
hollman@xtra.co.nz

Warren Ishii

Photography allows Warren to express himself to others and share what he thinks is beautiful or of interest. When his camera is in his hands, his spirits soar and he becomes inspired. Venturing into the digital darkroom is an extension of Warren's love for photography that he truly embraces. Here his photography is given added life, and becomes magical.

Pages 32–33
www.HawaiianIslandImages.com
haiku626@hawaii.rr.com

Mary-Ella Keith

In one way or another, Mary-Ella has been involved in the visual arts for as long as she can remember – either in the study of art, the teaching of it, or the creation of it. Since she went digital, photography has become an abiding passion. The instant feedback, the magic delete button and creative control from start to finish, continue to inspire her as she pursues this exciting and expressive artform.

Pages 104–105
www.mebkphotoart.com
mebkart@hotmail.com

Detlef Klahm

Detlef is mostly a self-taught photographer. Much of what he knows comes from trial and error. Some people believe a digital print needs to be something surreal, or like science fiction. Detlef, on the other hand, believes a digital image is an image where you start out with pixels instead of film. The end result is your idea on paper, regardless of how you started out.

Pages 22–23
www.paintwithlight.net
paintwithlight1@hotmail.com

Marco Pozzi

Marco is a paediatric cardio surgeon in Liverpool, UK. He has been taking and developing pictures for many years, but it is only in the last six years that he has taken photographs regularly. He started taking part in national and international photographic competitions a few years ago and won the Travel Photographer of the Year competition organised by Geographical two years ago and was second in the people category this year.

Pages 18, 48–49
mpozzi75@hotmail.com

Paul Rains

Photography for Paul is what he does along life's journey. Whether Paul is at home in the Missouri Ozarks in the USA or on an international trip, he enjoys taking photographs of people or a variety of other subjects. And the processing is as much fun as being behind the camera.

Pages 58–59, 60–61
www.paul.smugmug.com
prains@pol.net

Bjørn Rannestad

Bjørn received his first camera in 1986, at the age of 12. It was an Olympus OM 20 SLR. Since then he has pursued photography and is addicted to digital. Bjørn does not photograph any specific subjects, What drives him forward and makes his photographs better is the feedback from other photographers and the fun of competing in different photo contests.

Pages 130–131
www.rannestadphotos.com
rannestad@mail.dk

Jean-Pierre Romeyer

Jean-Pierre is 50 and discovered photography around 35 years ago. He traded up film cameras over the decades until in the summer of 2004 he bought his first digital SLR. Photography for Jean-Pierre is a way to express feelings and emotions.

Pages 76–77
romeyer.jp@eychenne.fr or
http://www.photo.net/photos/romeyer.jp
romeyerjpierre@aol.com

Mark Shapiro

Mark was born in Toronto, Canada and became interested in photography at the age of 12. He is currently living and working as a travel photographer in Vietnam. Mark shoots exclusively in digital and his current camera is a Canon 20D and he often uses the smallest and cheapest lens, the 50mm f1.8 as it is perfect for portraits and ultra lightweight.

Pages 50–53, 102–103
www.pbase.com/mkelpie
mkelpie@rocketmail.com
or mkelpie@gmail.com

Mirko Sorak

Mirko Sorak was born in Zagreb, Croatia. In April 2002 he bought his first camera, an Olympus C-200Z. Mirko didn't know much about photography, but started reading books and most importantly, practicing. Mirko likes all kinds of photography, but macro is his favourite. He has taken part in several photography contests, including HTMobile, Kodak photo of the day, Fotomag, DPChallenge, and Digitalfoto magazine.

Page 90
www.mirko-sorak.com
mirko.sorak@vip.hr

Erik Lundh

Erik Lundh lives in Portland Oregon and is married, 48 years old and loves the outdoors. He has been into photography since he was 18 years old. Erik likes to hike, fish, run, camp and do pretty much anything outdoors. He has run the Portland marathon eight years straight and ran Boston in 1999. He is a current member of PNWNP (Pacific Northwest Nature Photographers) and is a self-taught amateur.

Page 17

www.elphotography.net

elundh@comcast.net

Dave Martinidez

Dave Martinidez is a photographer living and working in New York City. He describes his approach to photography as an intuitive one. While he has embraced digital photography, he tends to see images in black and white, and utilises Photoshop to provide him with the tools that would be available to him in a traditional wet darkroom.

Pages 114–115

www.martinidez.com

images@martinidez.com

Heather McFarland

Heather retired in 2000 to pursue a second career as a photographer. She lives in Michigan, USA, and loves spending time photographing the abundant nature and scenic opportunities to be found there. Heather likes to photograph a wide variety of subjects, mostly the graphical elements found all around us.

Pages 40–41, 70–71, 78–79, 94–95

www.hkmphotos.com

farland@charter.net

Les McLean

Les has been a keen photographer for a number of years, but it wasn't until digital came of age, that his enthusiasm was rekindled. He particularly likes the instant feedback digital offers. Most weekends see Les strolling around the Yorkshire Dales, one of the most beautiful areas of the UK.

Pages 100–101, 134–135

www.lesmclean.co.uk

lesmclean@btinternet.com

Dolores Neilson

Dolores took up digital photography three years ago. Shortly after she entered photo competitions to improve her skills. The acknowledgement of her work by her peers has been a catalyst in her quest to achieve excellence in this field. Dolores lives in Connecticut, USA with her family.

Pages 84–85

www.photographybydolor es.com

dolores@photographybyd olores.com

Chris Pastella

Chris tries to combine photography with his passion for mountain climbing. His aim in photography is to capture not only the aesthetic side of nature, but also the little hidden clues, signs and symbols that make the subject speak our human language and bring it closer to us.

Pages 42–43

http://www.photo.net/ photodb/member-photos?include=all&user_ id=917551

chris.pastella@bluewin.ch

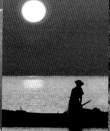

Thomas Muus Stensballe

Thomas was born in 1973, and grew up in a family of artists. When he was 15 years old his father bought him his first professional SLR camera. Today Thomas is a freelance photographer. In his photographs Thomas tries to capture the beauty of humanity and the wonderful world around us.

Pages 24–25

www.muusfoto.dk

muusfoto@hotmail.com

Mellik Tamás

Mellik is the joint owner of a small advertising agency in Budapest, Hungary. He uses a Fuji consumer digital SLR with a range of Sigma and Nikon lenses. He has sold images of his photography to clients and National Geographic Books. He also exhibits his images on Photo.net for critique by other members of the digital imaging community.

Pages 68–69, 124–125

www.photo.net/photodb/ user?user_id=928428

m.tamas@mellik-bako.hu

Marina Cano Trueba

Marina has been interested in photography since she was a little girl, watching her father developing pictures in the darkroom. Marina remembers images slowly coming to life under a weak red light. Today, Marina makes magic with her Canon digital SLR. She would like to dedicate this picture and all her photos to her father´s memory.

Pages 88–89

http://www.photo.net/ photodb/members-photos?include=all&user_ id=997968

Michael Ward

As a resident of San Francisco, USA, Michael often heads down to the bay area to photograph the Golden Gate Bridge. He started with a Sony compact camera, often shooting the bridge when storms when the sea was rough and the light was dramatic. He has since upgraded to capture scenes from home and around the world including Rome, Florence, Venice and Paris.

Pages 110–111

www.veelos.com/michael

michael@veelos.com

Julius Wong

Julius's passion for photography was rekindled in 2002 after he bought his first digital camera. The simplified workflow got him started shooting subjects other than friends and family members. Julius hopes to learn better techniques and recognise the potential in scenes that he would otherwise casually pass by.

Pages 26–27

www.photo.net/shared/ community-member?user_id=615322

julius@photo.net

143

acknowledgements

I would like to thank the following people for their hard work, belief and contributions to this book. Firstly, to Brian Morris for giving the project the go ahead and maintaining the strictest of quality controls on the images used. To Sarah Jameson for finding those images, which turned out to be a seemingly neverending hunt for photos that had been shot digitally. We got there in the end. To Natalia Price-Cabrera who had to pick up the project in mid-flow and made sure it carried on and got to the printers. Thank you for your patience! To Bruce Aiken, as always, for his intuitive grasp of colour and design, and also for discovering that I'd overlooked a spread just as the deadline approached. Phew, thanks Bruce. I'd like to thank Kerry, my long-suffering wife, for patience and understanding. Finally, to all the contributors who supplied information and great images, I thank you all.

Duncan Evans LRPS